MW01011474

NOTES ON A SHARED LANDSCAPE

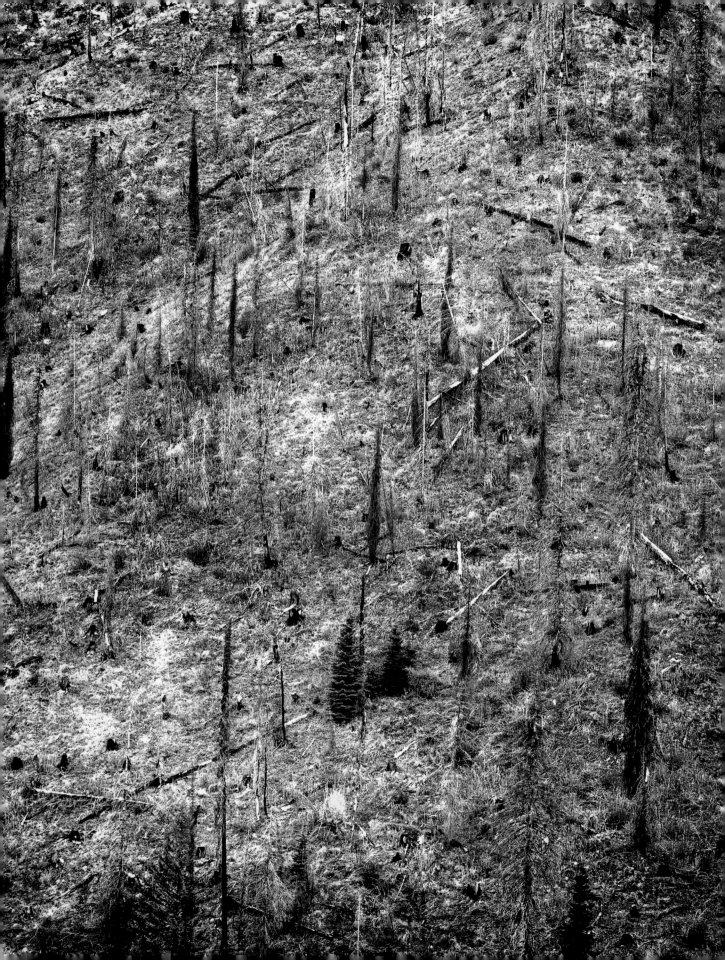

DAVID BAYLES

NOTES ON A SHARED LANDSCAPE

MAKING SENSE OF THE AMERICAN WEST

IMAGE CONTINUUM PRESS

SANTA CRUZ, CALIFORNIA & EUGENE, OREGON

Copyright © 2005 by David Bayles
All rights reserved

Library of Congress Control Number: 2004118301
ISBN: 0-9614547-4-1

(∞) The paper used in this publication meets the minimum
requirement for the American National Standard for
Information Sciences—Permanence of Paper for Printed
Library Materials, ANSI z39.48-1992.

Published by
Image Continuum Press

Distributed to the trade by
Consortium Book Sales & Distribution, Inc.
1045 Westgate Drive, Suite 90, Saint Paul, MN 55114
(800) 283-3572

Endsheets: Confluence of the Red River and the Rio Grande,
north of Taos, New Mexico
Page 2: Burned, logged slope, Lolo National Forest
Pages 6–7: Ponderosa pine stand after controlled burn

Printed in Singapore

CONTENTS

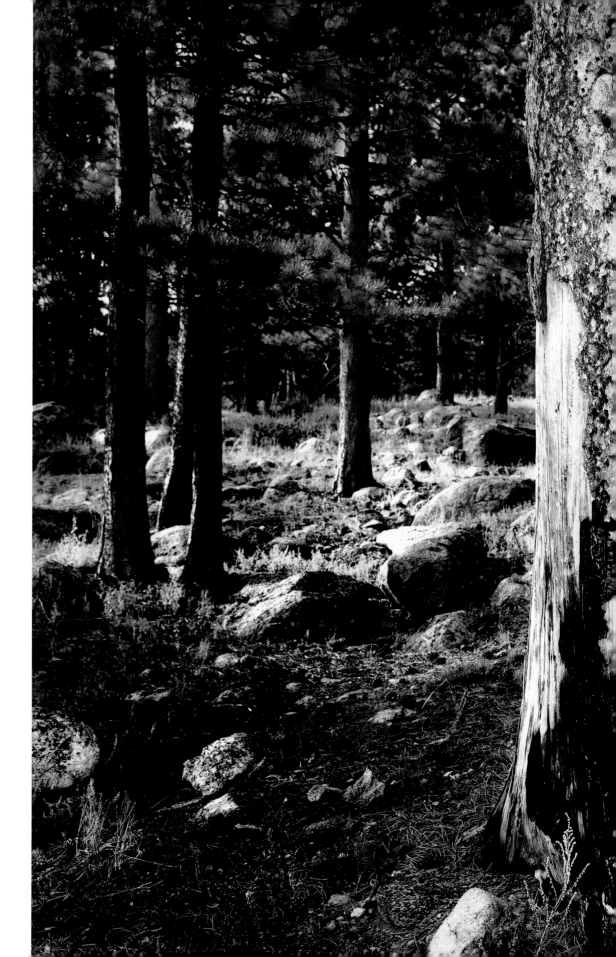

I am, we all are, beneficiaries of a shared landscape, and my job, all our jobs,
is to pass on the sharing, which I do particularly to my children, Shannon and Ezra,
to whom this book and my work on the West are dedicated.

Making sense of anything is seldom a solitary business. I read virtually all the successive drafts of this book to a small group of artists who get together faithfully once a month to share work in progress: Christina Florkowski; Saelon Renkes; Gitta Carnochan; Brian Taylor; my intellectual partner, life-long collaborator and intimate friend, Ted Orland; and my loving companion and contributor to this volume, Robin Voss Robinson. An occasional observer of this group, Bliss Carnochan, read and questioned some of this material vigorously, and if I have not answered his questions, it is not for want of trying. If this book makes sense, these people are deeply implicated.

Over two decades of travels together (the frequent drive from Idaho Falls to the Bechler ranger station in the quiet southwest corner of Yellowstone National Park, for example), Bill Hedden and I repeatedly and mutually speculated aloud on the passing landscape and the continuously evolving difficulty of seeing it clearly. Those conversations were and are sustenance for this work. Thank you, Bill.

Similarly, I have shared the western trail/wheel/oar/diner/rod/lens/streambank (and sometimes the creek itself) with Dave Bohn, DJ Bassett, Michael Daum, Steve Fend, Ashley Henry, Paul Hoobyar, Charley Dewberry, Chris Frissell, and with my family, Spencer Bayles, Philip Bayles, Ezra Spencer Bayles, Ginevra Shannon Poynter, Liana Baldonado Bayles, and John E. Poynter, who has climbed every peak on the horizon of the picture on page 100 and most everything else nearby (sometimes with my lagging company). I do not know how to thank Jack Slaughter and Ron Wohlauer, for they have moved on.

The highest function of a critic is to see the potential in a thing, and my tough-minded editor and friend Suzanne Kotz and designer Jeff Wincapaw brought critical economy and lyricism to every page of this work.

D.B.
December 2004

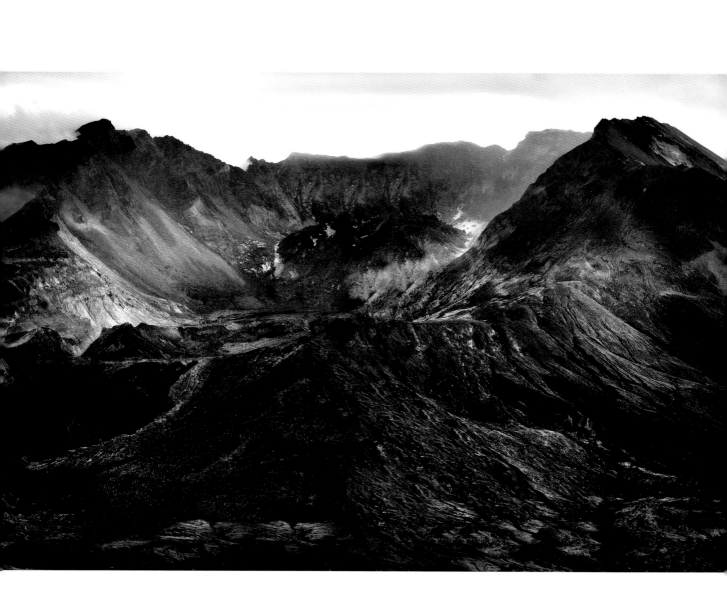

AN IMPERFECT FIT

I am concerned about the West and my place in it, if any—and I have had this concern since I was old enough to have any concerns at all. But it's not just me that I wonder about. It is the whole imperfect fit between a people—Euro-Americans—and a place—the American West—burdened with considerable mythology. In probing my concerns, I have been tempted to systematically distinguish the literal West from what might justifiably be called the mythic West, and to distinguish that in turn from the plainly ridiculous. But I find the edge of the fit is too rough for such exactness. A central problem in the West is that seldom are we able to say which is the view and which is the viewer.

Can one generation tell the next plausible stories about the landscape?

The question that drives most of this text is why we Euro-Americans bungled our occupation of the West so badly when no one really wanted to, when there was every chance to get it right, when voices of caution were constantly raised, when what needed to be done was frequently obvious, and when, occasionally, we did get it right (think: national parks).

My awareness of the place I have lived my life has gradually changed and slowly become more obvious to me. I think it matters that I am a Euro-American male westerner. I do not believe that the West was "natural" before my people took charge; after all, the continent we advanced across was as fully populated as means allowed and disease permitted when we arrived. The West has not been "natural" for thirteen thousand years—maybe more, maybe much more. It is hard for me to imagine that, in their great multiplicity and variety, native people routinely anticipated the consequences of their actions any more than anyone else has. Human influence on the western

◀ A NATURAL LANDSCAPE
(MOUNT ST. HELENS)

scene has clearly been significant for a very long time, but something recently has changed.

The change, I believe, is that Euro-Americans took over the West with enough literal and metaphorical horsepower to alter the landscape so substantially and so rapidly that one generation of ours cannot convincingly tell the next what that landscape is like. Our ability to alter the landscape is profound, unique—and in important ways, unrecognized—and has disabled us from coming to a deep familiarity with the land we love, even though we love it. I am not certain what exact kinds of knowledge are necessary or sufficient to make peaceful coexistence between a people and a landscape, but it seems plain that in this place some necessary parts are missing. The question of how we know what we know about the place we live will pervade the text.

We are the creators of our landscape (though we are generally unaware of the magnitude of our handiwork), but our creation is in enough flux that it is hard to compare notes on the landscape we share. My hunch is that for native peoples, lacking our power and our forgetfulness, this was not the case. The native grandmother could tell her granddaughter much that was true about the land, and that granddaughter in turn could tell her granddaughter the same plausible stories. That continuity—and not Eden—is what has been lost, and that sense of loss—just lost, recently lost, almost not lost—pervades the West.

I take it for granted that everyone understands we cannot have the West we want—a West of vital communities at ease in a magnificent landscape—without changing our ways. This is probably an error on my part, since we show little sign of changing our ways, and even less sign that we think we should. But we are neither particularly inclined to think about who we are, nor are we particularly skilled at it.

In general, I hope to use personal experience to illustrate the problems that interest me. This is partly to avoid describing the West in terms of good guys and bad guys, but more important, it is an attempt to show preference for tangible problems over theoretical ones. While using myself as a case in point should help cut down on ad hoc theorizing, it will not (and probably should not) entirely cure it. When I was much younger than I thought at the time, I took pride in knowing the answers. While now I take more interest in the questions, I still can't resist taking a shot at an answer when I see an opening.

I will cite personal experience as well because I am an ordinary product of the West, as many of you may be. If I have a problem, it is very likely that others have it too—perhaps many others, perhaps most others.

My ruminations have led me to feel increasingly certain that we Euro-Americans have a nearly universal, mostly inescapable, and inherently (possibly uniquely) western blindness: we neither see the landscape very well, nor do we see our own hand in it. This blindness persists despite our reverence, from the beginning, for the haunting scenery that surrounds us. I have come to understand that I, and perhaps you, see the West—the West we love—only darkly, only incompletely, like the glimpse of a face before it is lost in the crowd.

▾ BLAZED TREE, WILLAMETTE NATIONAL FOREST

THE LAMAR

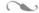

The veneration of special places is a central tenet of our created West, for better and for worse.

The Lamar River, which flows into the Yellowstone River in the northern range of Yellowstone Park, drains a landscape of extreme, apparent simplicity: snow-capped peaks—the home of bears; sere and rolling meadows—the home of bison; gravel-bar streams—the home of trout. The Lamar and its valley are deep in the nation's oldest national park, and is therefore one of our longest protected landscapes.

The protection has worked well enough. In the valley of the Lamar, unlike in most western landscapes, all the big native mammals still seem to thrive: where there used to be moose, there are still moose; where there used to be mountain lions or bighorn sheep, there are still lions or sheep. The pieces of the landscape fit smoothly together; there are no awkward gaps in the jigsaw. The valley is in such good shape that it was the first place where wolves were reintroduced to the West. So far the reintroduction is quite successful—the wolves have scattered and reproduced. Surely, then, this elemental scene is also a natural one. Surely it is what we would have seen had we been standing shoulder to shoulder with Lewis and Clark (had they strayed only a little distance and made this their route).

To make sense of the West, to see the landscape clearly, to recognize the mark of our Euro-American hand, to get an inkling of where you stop and nature begins, to note the things we share, to know where you are: for all this you need wild places and the natural landscape, the Lamar, for example. But careful unraveling is required if you are to begin to know which is you and which is the world, as an infant does, gradually discerning what is the self and what is not.

Any time is a good time to look up from the creek at your feet to the mountains at the horizon. But on the rare windless evening in the Lamar Valley, when the sun selectively lights the cottonwoods, such a look seems to carry the seer over that horizon, back in time to when the seen was the agent of change, not the seer.

The West is another name for nature, but in that name we seem to prefer a nature of special places and climactic moments. The grand gestures (the Book Cliffs, the Front Range, the Sierra Nevada, the Grand Canyon, and always Yellowstone)—or illustrations of them—are what we mean by nature. We count them among places where you can make sense of the West, or of yourself.

But perhaps not. Perhaps the grand gesture is just too much, or the resolution required is just too fine. Perhaps we make sense best when we make sense everywhere. To become more surefooted, we may need less veneration of special places and more intergenerational understanding of what is all around us. But if there are special places, the Lamar Valley is one, and it, like the whole West, is shared, as is the East, and the balance of the planet, and very likely all of creation. And while no other place is better for comparing notes, probably no other place is worse either, and probably no place is any different. Any place will do.

EXCLOSURE

On a sunny, south-facing slope midway up the Lamar River from its confluence with the Yellowstone, in an otherwise wide-open landscape, Park Service scientists have fenced off a few acres of land. "Exclosures," as such structures are called, fence out large grazing and browsing animals and are in wide use on public lands to track the effects of herbivory.

Outside the fence is a magnificently austere grassland, while inside is a Riot of the Vegetables, Northern Rockies Style—a profusion of outsized willows and aspen and a salad of other plants, seemingly larger, more vigorous, more robust, than anything else in the valley. The explosion of growth is so conspicuous that the fence almost appears to be keeping the trees in rather than the animals out.

From a distance, the fence itself is hardly noticeable. Up close it is both obvious and incongruous. In fencing some things in and others out, it creates a curiosity: a protected area within a protected area. Here, in the middle of the world's first national park, an exclosure is, in effect, a preserve within a preserve.

The fenced-out elk and bison are entirely natural, at least in the sense that they are native and belong here. (I use the word "natural" here in its commonsense meaning: not man-made.) The aspen and willow are natural as well—they and the grazers all belong here, eating and being eaten. The only obviously unnatural element is the fence (and possibly the viewer). But the more I consider the exclosure, the harder it is to draw conclusions; my grip on nature starts to slide. The exclosure is clearer on the ground than it is in my mind, and logic is slippery where nature is concerned. (Perhaps logic and nature do not belong in the same sentence. There is no inherent reason they

Nothing is wholly outside the fence, nothing wholly inside. Nature can be elusive even in a nature preserve.

◄ EXCLOSURE, YELLOWSTONE NATIONAL PARK

should.) Although since about the time of Newton we have tacitly regarded the world as rational, sometimes I am not sure it is even reasonable. I wonder: Is nature inside the fence, or outside it? Both? Neither?

Inside the fence, the vegetation is nature's response to (some) control by man. We fence the big herbivores out, and the herbs go wild. But outside the fence is also a mix of man and nature; in this case the herbivores are controlled not by fences but by far-flung policies such as the federal reintroduction of wolves and the State of Montana's ongoing war on bison. Arguably, "nature" is not operating either inside or outside the fence: the park is just a larger fenced-in area.

So where is nature? Is nature a question of place at all? In a world like ours, perhaps nature is something that happens when we build a fence and walk away for a while. What did the Lamar Valley look like in 1805? Is this landscape supposed to look more like what's inside the fence or outside it? How can we know? Why is it so hard to find nature in a nature preserve? Are most nature preserves like this? (I think that answer is "yes.")

I do not side with the recent line of thinking arguing (essentially) that nature is a fiction, and that "landscape" or "wilderness" (like all concepts) are no more than ways of organizing our ideas. These notions are simply wrong. There is an "out there" out there, and if you doubt that, take a walk through grizzly habitat at dusk or climb any reasonable-sized mountain in winter.

Sometimes the "out there" is right there. My friend Bill Hedden and I were charged by a good-size herd of bison not far from this exclosure. By crossing the middle of a vast meadow, hundreds of yards below a plainly visible group of bison, we unknowingly split a far-flung but nervous herd into two or, as it turned out, three groups—not a good thing to do with a large, fast, well-armed animal whose sense of security depends on being surrounded by the herd.

The farther we walked across the meadow—half a mile of waist-high grass—the more agitated the animals became, hundreds of yards away or not. Gradually they began to move restlessly, shaking their heads, scenting the air, and pawing the ground. Bill and I hightailed it toward the only cover we could see—a small group of trees—which, as we got closer, turned out to be guarded in the shadows by several old, black, bull sentry bison, with bloodshot Pleistocene eyes.

The meadow was large and wide open, but the bison were now clearly on alert. We somewhat desperately climbed a short rise at the edge of the meadow to escape the herd's line of sight, only to find, as Bill crested the rise a few

steps ahead of me, that the low hill hid hundreds of the rest of the frightened herd, who promptly charged.

We dropped our rods and packs and ran, literally for our lives, and levitated ourselves up into the only tree we could reach ahead of the herd, which thundered by inches below our trembling legs and did not stop until it reached the far end of the meadow, more than a mile away. Since that moment, if it ever had persuaded me at all, the charm of thinking that "wildness" is merely a concept has been lost on me.

Nature is not a fiction, but it does elude easy characterization. Our own doings are similarly elusive. We frequently, almost invariably, do not see our own hand in the landscape. We may not be man apart, but neither in our ideas nor in the field is it obvious where we stop and nature begins.

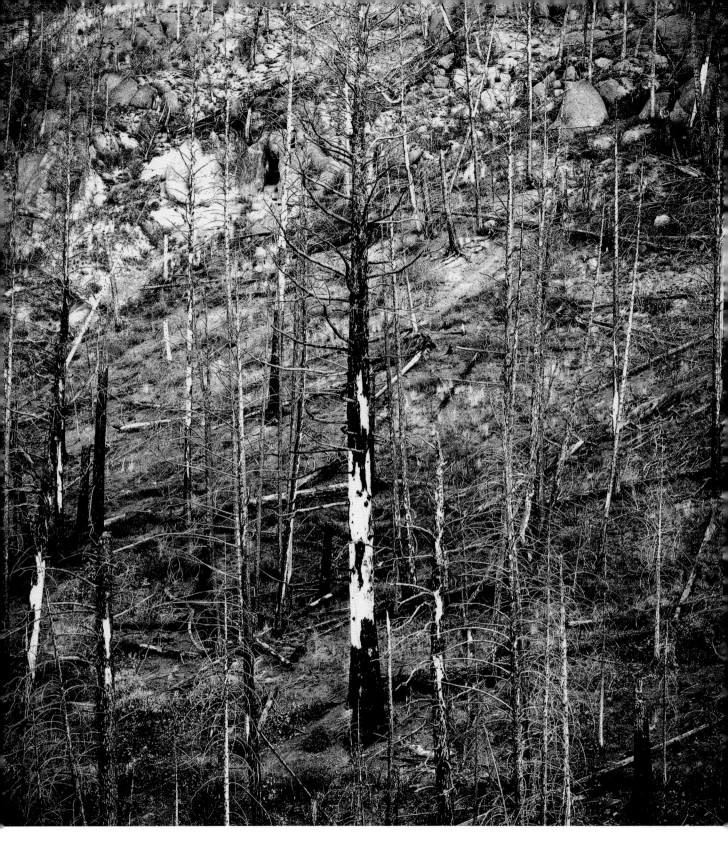

THE NEW WEST, OR MAYBE NOT

❧

"It was always this way, it was never that other way."

GRAFFITO, EUGENE, OREGON, C. 1985

The West that has come down to me—and to you—has been powerfully described by Frederich Jackson Turner as the aftermath of the moving frontier, and as cogently by Patricia Limerick as the legacy of conquest, but neither of these exactly tracks my experience. The West of my experience is a land of loss—of fragments, of blind spots, of reliance on vision despite a failure to see.

It is not that we defiled the Garden: the West was not Eden and was not lost once and for all. Rather in the West the new and the newly lost comingle, like anticipation and holidays, with no before, no after, no sense of foreboding and little of tragedy. The just lost, the imperfectly recognized, and the freshly minted combine to make a West that on balance is more fragmented than new, a West of succeeding glimpses, awkward moments strung together like an exhibition by a New York photographer.

Although mostly we love the land, we nevertheless have made irreversible errors with it, and we are (perhaps for the first time in history) a people both powerful enough to set a landscape on an entirely novel trajectory and oblivious enough to avoid being particularly mindful or even aware of the changed arc. But perhaps we *do* see, or could, and perhaps it is not a failure of vision. Maybe it is a more ordinary love affair, marked by the familiar mix of inattention and looking the other way.

The West is not the product of farce or sin, but of the tragedy, that, for a time, it seemed it could have been different.

◄ DOUGLAS FIR, MADISON CANYON, YELLOWSTONE NATIONAL PARK

[21]

While the losses in the West might have been avoided, they were not avoided. Things went wrong even though they did not have to—much as in routine tragedy when, from the moment the curtain ascends, the certainty rises in you that although things could turn out well, they will not. The central irony of the American West is not that we got it wrong, but that we mostly meant to get it right.

The porch of my grandparents' house at 1408 Kentucky Street, Lawrence, Kansas, was built with lumber brought from Missouri to rebuild the town after Quantrill's Raiders burned it to the ground in 1863—a time when Kansas (Bleeding Kansas) marked the moving edge of the West. On that porch, on summer evenings after dark, my great-great uncle the Honorable Hugh Borden Means taught me how to play cribbage, and how to keep fireflies alive in a jar. He had known several Civil War veterans well. He had known a man who had known Lincoln. I really am uncertain whether the West is new or old.

But it may not matter: we all know that there used to be many bison (salmon, meadows, silence), and now there are few. We know these things although for the most part we have not experienced them—which makes the West, with all of its promise of experience, oddly more a place of knowledge than of experience.

On the other hand, we almost experienced it. The bison and the salmon are so recently gone that the dust still hangs in the air, and the mist has not yet lifted from the river. The large dark stumps are still moldering in the woods.

The West is not the East, and it is not Europe, but, ironically, the difference does not lie within the landscape, however marked, however charged, however revered. The difference is that the losses in the West are so recent and the handiwork of people so much like ourselves that the outcome seemingly could have been different.

But it was not different. Looking out, we should see the mark of our hand on the land, but with exceptions, such as dams or clearcuts, we mostly do not. We have not acquired the fine-grained recognition of our place or of our handiwork as we have for, say, the faces of friends. As a people, we reacted to a landscape of overwhelming beauty and power by surrounding ourselves with ourselves. Robert Frost was twice wrong when he wrote "the land was ours before we were the land's." Neither has occurred.

We traded the West we found for the West we made, but we were not (and are not) knowledgeable traders. From the moment we arrived, we began dealing cards we could read only in good light, and we continue to deal them, not seeing much better, so that our occupancy of this gilded place is of a piece, continuous, marked by irony and change, yes, but not by episode: the West is not paradise lost, neither suddenly nor gradually. Each moment since our arrival has no precedent because no thing repeats or can repeat. It was always this way, never that other way. No old West, no new one.

Perhaps it is not yet time to come to conclusions. Making sense of the West may still be a generation or two away, or more. Why now, after all? The West we have inherited (and simultaneously created) may be so contingent, so circumstantial, so imbedded in particulars that themselves are matters of happenstance that any coherent explanation is likely to overdetermine the case. Uncertainty is a hard thing to get right.

Likely, this is just another moment, neither more nor less portentous than any other, and at such an ordinary time there is no reason to think the West is ripe just now, this way.

MEET THE NATIVES

*When I know where
I am in the West,
I have my family, not
my culture, to thank.*

My mother's mother, Maribelle McGill Monahan, lived most of her life in Topeka, Kansas, a home base from which she traveled virtually the entire West by car, beginning in the 1920s.

She was well educated, one of the few women of her generation with a university degree (University of Kansas, 1916), and she carried herself with the dignity of late-nineteenth-century middle-class America, which was considerable. One of her classmates was my other grandmother, Lucene Allen Spencer. I have the benefits and probably the quirks of being descended from a long line of women who not only valued education but got it and gave it in no uncertain terms, as they did much else.

Almost invariably Maribelle wore dresses, her favorites of which were printed abundantly in the correct violet and lavender hues of the native penstemons, and even more so of the wild delphinium—usually called larkspur—that grows in western wet spots as varied as high mountain meadows in Wyoming and low riversides in Oregon.

Maribelle recalled to me once that she was driving in Wyoming in the 1930s and came around a bend to see an impossibly blue lake, which, on closer view, turned out to be a field of larkspur so dense as to appear solid from one apparent shoreline to the other.

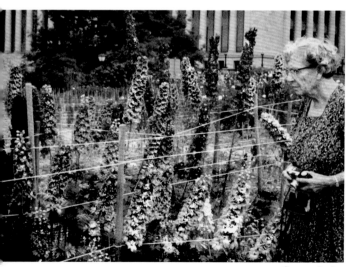

Spencer Bayles

There are a very large number of difficult-to-distinguish western penstemon—perhaps two hundred or so—and I do not try to identify them as to species. Maribelle would not have disapproved of my laxness, despite the obvious intensity of her relationship with the natural world, wild and tame. I asked her once if she kept track of flowers by their botanical families. She replied that she had stopped trying to remember that kind of information when she learned that Spanish moss and pineapples were in the same family.

Her daughter Virginia, my mother, also traveled the West by car and also understood the West partly through those same wildflowers. In the beginning she learned them from Maribelle but moved on to make her own assiduous observations. She learned them well enough that in a year of average moisture in Rocky Mountain National Park she could predict to within a few days and a few feet the date and location of the first blooming not just of the showy blue columbine in the lower elevations of, say, Wild Basin, but of the dwarf white alpine columbine in the tundra and rock cuts above timberline on Trail Ridge Road.

The last gift my mother gave me before she died was her fourth copy of *Meet the Natives*—the first three being worn out long before from identifying wildflowers in the field. She filled the margins of the fourth copy, like the other three, with field notes of wildflower sightings; unlike the others, the fourth copy is inscribed pointedly in the shaky handwriting of the terminally ill: "To David, with much love, and some reluctance. Christmas 1995."

Meet the Natives is organized like no other flower guide I know, relying on the logic of an experiential geography that makes perfect sense in the mountains—the flowers are grouped not by some botanical consideration, but first by altitude, and second by color. If you are hiking at ten thousand feet in the Front Range of the Rockies, and the flower before you is sky blue, there are only a handful of choices.

To this day I know where I am in the West partly by altitude and partly by color. From my birth to her death, my mother and I were never together in the mountains without a copy of *Meet the Natives*. I know where I am not from my place in the society but from my place in the family, and from the lines of contact my family developed or failed to develop with the landscape.

Particular kinds of families favor particular kinds of knowledge. When I walk in the woods I know the names of some of the flowers because of my family, not my culture. My connection to what's-out-there goes through pages

◄ STALKING THE TAME
DELPHINIUM

arranged by altitude and color, and through shaky notes in the margins, not through Western European landscape iconography. In my family you are expected to know the names of some of the flowers—and while knowing the names of the flowers is not interpenetration with the land, it is not nothing either.

Maribelle had an astonishing memory, and her command of detail was prodigious. We were having lunch one day late in her life—she was roughly ninety—and were talking about her travels, which by then had expanded beyond the larkspur-filled lakebeds of Wyoming to include the Nile, the Danube, and the Amazon (which she floated in her eighties). I happened to ask her if she had ever seen a mountain lion in the wild.

"Yes," she said without hesitation, "on the road that runs from Kanab to the North Rim of the Grand Canyon."

"When was that?" I asked—our conversation being in about 1984.

She paused less than two seconds before answering.

"Well . . . Willard [her late husband] bought the Ford in '34, and we went to California that year, but we didn't go through Kanab. So it would have been the next trip, in '35. (Millisecond pause) . . . in July."

I decided to press the issue: "When in July?"

"Well. (Another pause, probably nanoseconds) . . . Well . . . we got to California two nights before the wedding, which was July 12, so we would have left Kanab on July 8."

"What time?"

"Before lunch."

I couldn't resist. "Well then, what did you have for lunch?"

While Maribelle deigned to answer my impertinent question, she did so with a pointed look of disapproval. "I am not *sure* I remember, but I think we bought groceries in Kanab, and had a picnic lunch beside the road."

▶ UNIDENTIFIED PENSTEMON,
 WYOMING

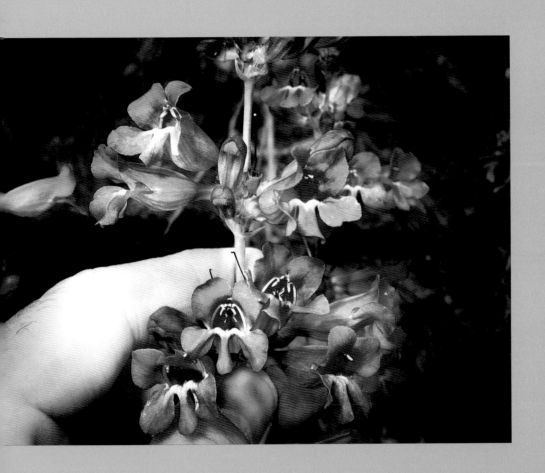

ASHES

෴

Under our unconscious supervision, successive generations are assigned different landscapes.

Like virtually all wildfires, the 1988 Yellowstone fires were a patchwork of intensity, burning hot and complete in some places, but relatively cool and incomplete in others—not to mention patches that were hot and incomplete, cool and complete, and so on. In some patches, only fine material was scorched; in others, fires burned up draws to the ridge top, sparing nothing. On the lower Gibbon River, the fires were a notch below ferocious—but just a notch. There is hardly a large living tree left anywhere in thousands of acres of this landscape except a few along the river's edge.

The living trees inside the big horseshoe bend in the photograph survived in this just-short-of-holocaust patch because of their topographic setting—their place in three-dimensional space, so to speak. Since heat rises, fires travel best uphill. A fire's uphill tendencies mean that the lowest parts of the landscape—the coolest, moistest places, the places along the edge of the river, where you are most likely to want to picnic on a hot day—are the places least likely to burn, or the least likely to burn at tree-killing intensity. Fires can and do travel downhill, but sometimes lose their edge as they do. Everything else being equal, the trees adjacent to the stream are the trees most likely to live through a fire. Nature is messy, however, so things are seldom equal.

I have lived in the West all my life and worked in river conservation for a good piece of time before I was able to notice such things as the distribution of living trees after a burn with any consistency—before I was able to see clearly that the bank of a river is a place where surviving a fire was a lot more likely than in others.

Only gradually, and only with a reasonable amount of conscious effort, have I learned to see in the landscape what I now cannot help but see. In other

▶ LOWER GIBBON RIVER,
YELLOWSTONE NATIONAL PARK

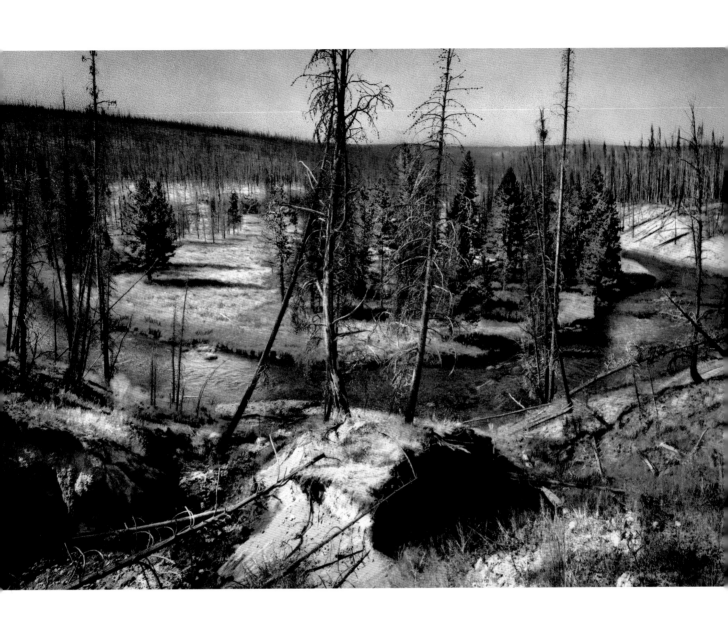

words, what I see is sensitively dependent on choices I have made—it did not happen by itself.

My mother and I shared a common affinity for tragedy, but we did not always share a view of what, exactly, was tragic and what was not. Heading back east after following the Lewis and Clark route to the Pacific, she visited Yellowstone not long after the 1988 fires. She was not only appalled by the extent of the fires themselves but was deeply offended that someone (anyone) would have wanted to let these or any other forest fire burn, never mind those in a national park. (Although argument about a let-it-burn policy can be legitimate, for the record, the Park Service did not let the 1988 fires burn—the fires were fought valiantly, aggressively, expensively, and with the exception of the rescue of historical sites like Old Faithful Lodge or of populated sites like Cooke City, perhaps fruitlessly.)

Equally, my mother and I were rarely short of opinions. I thought the 1988 fires and their aftermath were beautiful, and I said so, which considerably offended her. (She was not offended *that* I said so, of course. It is a blessing to have had a mother who cares about the content of your thoughts, not their expression.) Her offence about the fires was not a matter of choice any more than my liking them was. You cannot look at a landscape awash in ashes from horizon to horizon and freely choose your response, and neither could either of us. Some things pass through us like light through water.

I notice the living trees along the river because of the life I have lived and the work I have done, while the beauty I see in fire and the burned landscape is a gift; it is not of my doing. Some of what we see is the consequence of conscious choice, but other things seen are given to us, residing in our guts, with all the power and intolerance of truth received, not earned. Received truth does not lend itself to reasonable discussion, as we continue to find over and over. My conversations with my mother about the fires were not easy.

One generation is not a lot of time, and should not be enough time to produce people whose gut senses contradict each other. But as we all come to learn, one generation is enough time, and it happens every day.

BIOPOLITICAL REALITIES

I am generally a big fan of the Park Service, but it sometimes stumbles on science. One of my earliest encounters with the Bermuda triangle of science, law, and the Park Service occurred during the unprecedented pine-bark beetle epidemic of the 1960s (not the unprecedented pine-bark beetle epidemic of the '70s, nor the one in the '80s or the '90s . . . this was the one in the '60s). In any case, I was driving into Rocky Mountain National Park one morning, and I noticed men with chainsaws cutting down trees on the hillside behind the entrance station. I was about eighteen years old, but nevertheless I eyeballed the ranger and said, "You can't log trees in a national park." He looked at me the way the sheriff looked at Paul Newman in "Cool Hand Luke," and said, "Son, those trees got bark beetle; they're dead and they're ugly, and you can see them from the entrance station, and what's more you can see them from the superintendent's house, and son [slowing his cadence slightly for excellent dramatic effect], they're coming OUT of here, and that's just a biopolitical reality."

The West is the world's longest running conscious test of the politics of biology.

SEEING THE LIGHT

The testimony of
eyewitnesses is not
objective, but is limited
by what they can see.

In my earliest days of photography, before I knew any other photographers (except possibly Ron Wohlauer), the local drugstore camera dealer encouraged me to learn good photographic technique by following the instructions in the Basic Photo Series by Ansel Adams. As hard as this may be to believe, Ansel Adams was not particularly well known in 1967. While the books in question had been out for more than a decade, the great Adams ascendancy was yet to come and his technical books were not all that easy to find. Ansel's approach was daunting, but it was seductive for a self-consciously righteous, bookish, headstrong, confident person like me—confident despite the fact that I knew essentially nothing about photography.

I met Ansel at his house in Carmel Highlands about two years later. I had written to him requesting a consultation on my work, and he generously and promptly wrote back that yes, I should ship some prints ahead and come visit him at the house at Yankee Point on such and such a Wednesday. I did. We sat in a room that overlooked the Pacific. His longtime employee Jim Taylor poured us each a glass of whiskey strong enough to stop a bullet, and before opening the portfolio, we sipped the powerful drinks and watched the sun set, looking for the green flash.

Later, as the conversation about my photographs began to wane, Virginia Best Adams—Mrs. Ansel Adams—joined us. I had noticed dinner preparations going on in the next room, and I was sure that she was about to extend an invitation. She gently commandeered the conversation and engaged me quite directly. Within minutes, without any break in our effortless chat—and without my knowing how—my portfolio was packed, strapped, buckled, and tucked under my arm. I was thanking the both of them and letting myself

out the big front door. I had driven a good portion of the way back to Carmel before the depth of Virginia's social skills began to dawn on me.

The very first lesson from the Adams book was humbling. Ansel's instruction for managing light was to take an exposure meter reading first in the shadows, and then in the highlights. So I stepped out of my Boulder, Colorado, door, light meter in hand, into a world that in that instant was fully and brilliantly illuminated, for the first time. I could literally see the light—not just the obvious light of the direct Colorado sun, but the softer light reflected off a whitewashed wall, and the still softer light from a small window in a darkened room.

Before I opened that door, I had never really seen the light (unless you count showy light displays like sunsets and rainbows, which I do not), and now I stood, textbook in one hand, light meter in the other, seeing nothing else. All I needed was to be told how—or maybe why—to look.

But I did need to be told. Maybe others don't need to be told, but I don't think so. I think the underlying phenomenon is worth pondering. If how I see the world (not how I regard the world, nor how I think about the world, nor how much I value this or that)—literally how the world looks to me—depends sensitively on my particular life experiences—the use of a handheld light meter in the Boulder sun, for example—then shared vision may literally not be possible. If having a shared vision of the West is a necessary part of the solution to our culture's demonstrated inability to make peace with a landscape we love, we may have a tough time of it.

Steve Fend and I were hiking recently in a poison-oak infested part of the interior coast range in California and chanced across a couple coming up the trail who were desperately worried not to touch the poison oak (the toxic Pacific Coast species of poison ivy). They were rather loudly discussing the plant beside them on the narrow trail—a wild berry—and, thinking it was poison oak, arguing about how to avoid it. Steve is an aquatic entomologist and a born-and-bred naturalist, and his general field knowledge is superb. He pointed out the actual poison oak growing practically adjacent to the berry the couple had misidentified, but to our utter astonishment, neither of them could tell the two plants apart. It is true both plants had a rough three-part character to their leaves, but nothing else about the leaves or configuration of the plants was similar (to us). They could not see the difference in gloss, the serrated edges against smooth ones, or a ruddy versus flat green. The conversation continued awkwardly a few minutes, without our helping them a whit. We moved on.

Seeing is probably circumscribed not by what there is to see, but by the life history of the seer, and if so then we may need to have more greatly shared life histories (more shared experience) if we are to see the landscape—or anything else—the same. Cultures whose members have greatly overlapping life histories—cultures greatly unlike ours—may be the only ones who can share an understanding of the landscape they inhabit. Culture is, among other things, the product of shared experiences and shared expectations, and does not exist without them. If berries and poison oak are telling, it appears that there is insufficient shared experience for us in the West (literally) to see things similarly, and in that failure, a real western culture and real communities are going to be difficult.

KINGSNAKE

I have only seen two California kingsnakes in my life—one in a book, and one just before it died. Perhaps it would be more accurate to say that I have never seen a California kingsnake, but rather two images of kingsnakes—one on a page, and one in the headlights.

The first kingsnake was in the Golden Book of Reptiles and Amphibians, in which each of America's common snakes and such was described and, more to the point, depicted as distinctively as possible to aid in identification at a glance. The illustrations were—appropriately—paintings, not photographs, since a painting can depict generalities better than a photograph can, as a rule. Forty years and two-tenths of a second later, I learned just how accomplished those paintings were, and, on reflection, I learned about the complexity of the image and the thing imagined.

In the Golden Book, the snakes were painted vividly but the backgrounds were muted, so that whether it was the corncrib behind the gopher snake, or the swamp behind the cottonmouth, some hint of habitat for the critter was suggested without too many specifics. Implicit in the illustrations was a theory of how the human mind works—to the effect that clear images on drab backgrounds aid rapid recognition.

Time spent lost in a book of paintings of snakes was the best of childhood. Like time spent in mountain meadows or in the woods, it was hypnotic time, when the clock hands didn't move. Even as a child ardently looking for snakes, without a view of myself or of the world, I somehow knew that contact with nature often merges with images of nature, and that knowing is, for better or for worse, inseparable from the painting, the image, the scene, the

Nature and the image of nature can be difficult—or impossible— to distinguish.

likeness, the view. Maintaining the distinction between nature and images of nature requires more mental effort than you would think.

We make sense of the world by continuously piecing together plausible pictures and plot lines from an unceasing blizzard of memory and sensation. We do this in every time scale, from that of a lifetime—where the story is our life—down to the timeframe of ordinary vision—where the story is the changing scene before us. In daily vision, five times a second or so, we freeze the most plausible frame we can from what's available. Five times a second or so an electrical wave washes through us, and we highlight the foreground, mute the background, and thereby see, hear, taste, smell, feel the breeze on our skin.

The business of being unfolds in endlessly overlapping pictures. You fit together all the pieces you can, and neglect the rest. Several times per heartbeat, over and over from birth to death, you weigh plausibilities in an instant and decide which is foreground and which is background, which is the specific and which is the general, which is the snake and which is the habitat. Not every sensation fits and not every memory belongs. Being conscious is choosing essentials and neglecting the rest. To place something in the foreground, you need just so much memory or sensation. A glimpse of a kingsnake is enough.

A kingsnake is a heavily banded snake, with vivid contrasting markings. This heavy pattern surely blends into the busy mosaic habitat of chapparal and digger pine forests, where such sharp contrasts are the universal pattern, and one more isn't conspicuous. But in the Golden Book of Reptiles and Amphibians, the background contrasts were muted, and the California kingsnake stood out rather than blended. A heavily banded snake is similarly conspicuous against a patch of dull gray asphalt, even at dusk, even on a blind curve of a fast road.

Now and then experience itself is in sharp relief, heavily banded and separated from a muted background. It is tempting to locate the image of my first kingsnake only in the book, but that attempt fails as soon as I try to locate the second one only on the road.

AN OBSERVATION FROM THE FIELD

Afew years ago I made a five-day solo white-water raft trip down the main stem of the Owyhee River. The Owyhee drains a huge expanse of high desert sagebrush steppe and higher yet desert mountains in northern Nevada and the border country of Oregon and Idaho. Psychically speaking, the Owyhee is pretty far out there, and "alone" on the Owyhee in the early spring before snow melt starts means really alone. The next boat down the roadless canyon was eight days behind me.

I went to the Owyhee with no express purpose, and while certainly I wanted the increased edge of awareness that comes with objective danger, I am not an adrenaline junkie, and risk was not my object. I took obvious steps to keep dangers down, with the result that, heart pounding or not, I scouted and passed the big rapids uneventfully. Uneventful is a really good word on a solo trip.

But being alone in itself does heighten awareness, and by late in the third day my sometimes dull senses (of hearing and smell in particular) came alive. I could begin to hear minute variations in the roar of the river accurately enough to aid my rowing, and to my utter astonishment, I could smell the freshwater of a small spring from my raft in mid-river as I floated by.

And as senses rise, consciousness falls. The chatter in your head dies down and absorption increases; the meditative, unselfconscious, suspended-animation mind takes over. Hours pass; you do not notice. This is probably what consciousness was like before there was so much of it.

I had given in completely to the quiet mind by the fourth and fifth days; in fact, in tangible detail, I remember very little of that seamless time. But the Owyhee River gradually disgorges into a narrow reservoir, and while the

This may have been what consciousness was like before there was so much of it.

transition out of the wild is gradual, the mind reasserts itself quickly. Something vague began to put me mildly on guard. I leaned into the oars, a little anxious to cross a long pull of flat water. I had not heard the sound of another human in five days.

Then, faster than I can describe, a distant roar in the east (too throaty for wind or water) increased rapidly. Turning toward the sound, I caught a glimpse of a hunter in the brush, and a glint of sunlight off a rifle barrel. A shot echoed, a rabbit squealed, and the roar became the blast of paired jet fighters coming down the canyon, nose to tail, in camouflage paint, very fast, very low. They acknowledged my lonely and obvious boat with snap wing dips as they passed, deafeningly, directly overhead. The scent of burned jet fuel hung in the air for hours.

〜

If culture is the sum of a people's shared experience, then we might want to be intentional rather than passive about what we share. If we do not take a firm hand, we are likely to develop more of what we have now—a sort of Hayden Valley Culture where, against a backdrop of one of the earth's beautiful landscapes, we play out chaos, confrontation, and ignorance. I am not sure any group of people ever deliberately chose how to share a landscape, but we should probably try. If we don't, traffic will eventually come to a complete halt and we will have to walk. I am certain we can do what it takes to avoid that, and I don't mean just traffic. Traffic is just a metaphor.

Some consideration will eventually be given to the alternative: having to walk.

▾ HAYDEN VALLEY TRAFFIC,
YELLOWSTONE NATIONAL PARK

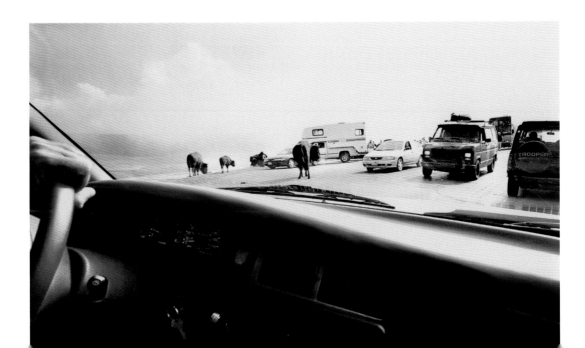

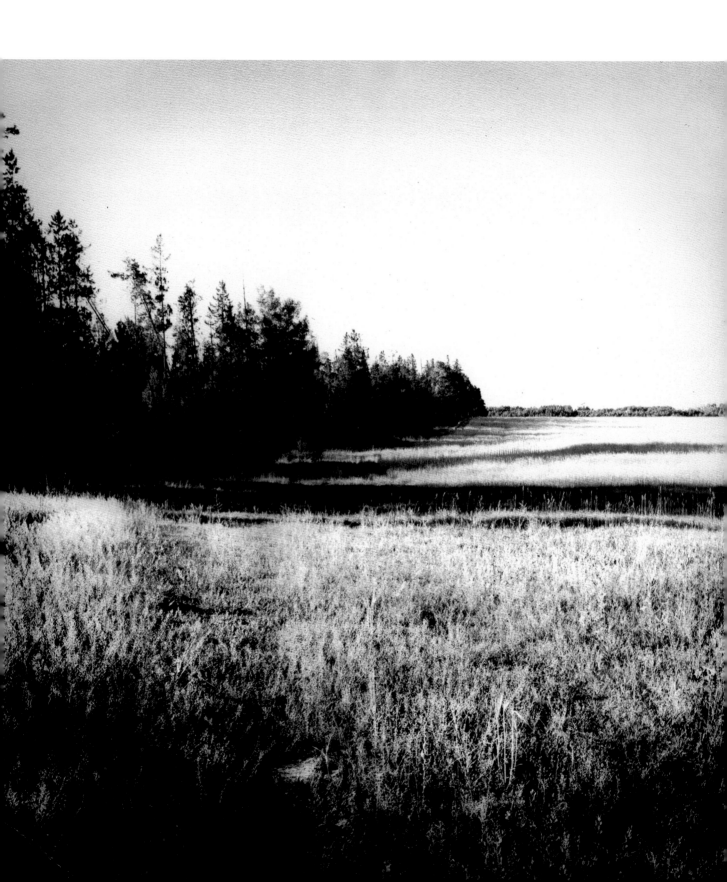

THE TWO-COLOR MAP

For reasons that are too depressing to recount, bison that unwittingly wander out of Yellowstone Park in winter run a good risk of being shot by agents of the State of Montana. For the bison of Yellowstone the largely imperceptible line between protected and unprotected land is truly consequential. An equally insensible line will probably have been drawn for wolves by the time this paragraph is in print. For elk, deer, antelope, bear, coyote, what-have-you (not to mention plants), lines have been in place for years. America's national park system, while arguably the most influential conservation idea ever actually implemented, is not without a shadow. Weaknesses inherent in the parks appear inseparable from the parks' strengths.

The seminal park idea—that special places in the landscape ought to be preserved for the public and unimpaired for future generations—has 150 years of momentum, and is echoed worldwide. The momentum is carried on broad shoulders: "preserved" and "unimpaired for future generations" are the hefty ideals of Yellowstone's congressional charter—idealistic and confident concepts, typical, perhaps, of the more colorful threads in the Euro-American cloth. But while "special places" is an equally large idea, its shadows are more pronounced.

Treating anything as special inherently divides an arguably indivisible world into at least two pieces: the protected and the unprotected, the special and the ordinary, the raw and the cooked, so to speak. Implicit in such division is the belief that some virtues are independent of their context, and that some entities can be manipulated in isolation—nature, for example; us, for another.

There will come a time when accurately depicting the West will require only two crayons.

◄ THE RAW AND THE COOKED, EASTERN IDAHO

The founders of the parks were comfortable with the idea of special places, as are most people today. They fully intended to protect the extraordinary; the rest would be grazed, farmed, logged, mined, or developed. And indeed it was. Thinking that the world can be divided into the sacred and the profane may be self-fulfilling.

Today, to color a meaningful map of the West only two crayons are needed: a shade of green for the protected areas, and brown for the rest. It is the simplest possible picture of a shared landscape, and, if it is desired, an elegant, if dubious, conservation formula—robust enough that recent habitat conservation plans, designed to balance species protection and housing development in fast-growing areas, for example, sometimes have only two essential land designations: fully developed or fully protected.

While it may be a bit premature to say that the West may be fairly depicted by a two-color map, even a more forgiving, optimistic, and nuanced map requires only three crayons: one for protected, one for developed, and one for the multiple-use lands (mostly federal) that serve conflicted masters. The third crayon should be a muddled color—perhaps a greenish brown or olive drab.

In the nineteenth century, special places were protected to preserve scenes of wonder and curiosity, and scenery (more than curiosity) remains the central desideratum of special places. In a national park, all roads lead to big views. Over time, protection of scenic places has been augmented with protection of historically and culturally important places, but not without some residual feeling that the parks—the Washington Monuments and the Gettysburgs—aren't "real" national parks.

The park founders' unvarnished view of themselves compelled them to put constraints on their acquisitive, self-interested free market character—the part of the American character so revered and overestimated by neoconservatives. It was a moment of great cultural candor, since protection of the parks was an admission that scenes of wonder and curiosity *need* protection—from us.

Protection of special places is noble only in a world where ignobility is potent—such as for a people like us, who likely would not pass on intact what was given to us if not for a rule that prevents us from being our natural selves. Protecting public parks is only necessary if people cannot be trusted to take care of the land for its own sake. If we knew (if the park founders had known) that we would treat the landscape gently, if we recognized our own mark on the land, there would be no need for national parks.

Our predecessors' cool, skeptical, and apparently accurate assessment of the Euro-American personality fortunately placed America's parks out of the reach of most private enterprise. It hasn't worked perfectly, but it has worked well enough.

Curiously, the parks are more sophisticated politically and culturally than they are ecologically. (Parks are biopolitical realities, like everything else.) Since the major era of park creation, we have learned that some critters can't thrive in scattered special places; no matter how well protected, some of them need a connected landscape. Similarly, fundamental processes that drive the health of the ecosystem (like the flow of water through the landscape) cannot be maintained by the protection of special places—by exclosures, if you will. Ironically, protection of special places—necessary because people can't be trusted to care for the whole landscape—partially fails exactly because it doesn't address the whole landscape.

Nothing is entirely inside the fence, and nothing is entirely outside the fence. It matters not just to the bison that the boundaries are not always visible on the ground. If we are to have the West we want (let's say: thriving communities in a beautiful landscape), we must move beyond thinking about special places to embrace the role each place plays in a larger West. To have the West we want, we must practice meaningful conservation not just in parks but on every farm, ranch, suburb, forest, grassland, backyard, park, or parking lot. As much as some people don't want to hear it, each of us, and every piece of ground, has a contribution to make to the common good.

The two-color map we are currently drawing will not work. There is only one creation, and every piece of it matters. Everything is connected to everything, every seat has a good view, and there are no special places. It's all special—or all ordinary, if you prefer—but either way, it all counts.

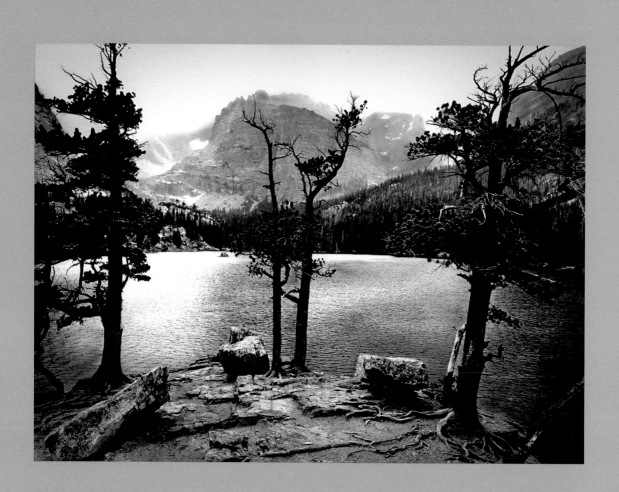

THE "LOCH"

The "Loch" in Loch Vale is a glacial lake (like high mountain lakes everywhere) and presumably resembles the lochs in the glacial vales of Scotland, from which, through some undoubtedly circuitous route, this Colorado lake got its name. When I was a kid, this lake was full of native greenback cutthroat trout, a rare trout so deeply colored that males in their spawning colors look like escapees from a tropical aquarium. When I was in my thirties, Loch Vale was full of non-native brook trout, and today, to my astonishment, the native greenbacks have been successfully reintroduced. This flip-flopping of a major species in a small lake means that major changes occurred twice in my lifetime in the who-eats-whom dynamics of the lake's ecosystem, both times a result of human intervention. We killed off the greenbacks by our introduction of brook trout, and then had to kill off the brook trout to reintroduce the greenbacks—all this in a national park.

The changing face of nature—in the form of fish—in a national park.

◂ LOCH VALE AND THE
CONTINENTAL DIVIDE,
COLORADO

IN WHICH ADAM TRAVELS WEST

⟳

Our shared landscape has never looked this way before; it never will again. The Garden is always new.

The redwood forests of the Santa Cruz Mountains, like all forests where really big trees dominate, are dark, quiet, and moist. They are cooler in summer and warmer in winter than the surrounding landscape, and they are layered with light. The cascade of foliage traps every possible photon, creating a luminous architecture that is brighter above, darker below, and brighter again on the forest floor.

In this forest, the large trees are huddled in rough circles called fairy rings, and in the center of each ring is the moldering stump of a much larger, much older tree that was logged out of the forest eighty, a hundred, or more years ago. Today's trees are the grown-up shoots from the base of the big logged tree—the huddle is a ring of eighty-year-old sprouts, so to speak. Since an eighty-year-old redwood sprout in the well-watered parts of the Santa Cruz Mountains is a big tree, this landscape of sprouts is actual forest, but an odd one—a forest of three- or four-foot-diameter trees holding hands around dark and rotting stumps.

Never before was there a forest like this. It is not a tree farm or a tree museum, but rather a forest of Euro-American creation. (Native Americans made all kinds of alterations to the landscape, but they never logged all the big trees out of the woods all at once, thereby setting this forest in motion.)

We did not plant this forest, we did not plan it: we logged it and left it, and a forest never seen before rose in our wake. It is a forest of unintended beauty. The fairy rings are shapely and rhythmical, but their shapes are unpremeditated and their rhythms accidental. A design without a designer, so to speak.

When I speak of a landscape of our creation, I am not referring to the domestication of the West, and I am not thinking of pavement and

subdivisions. It is, ironically, the wild and nearly wild places I am thinking of, that new species of wildness which (oddly and uncomfortably) has our hand, however unknowing, in its arrangement.

For a number of years, the conservation group American Rivers published a beautiful annual poster—modeled, it would appear, on the Sierra Club calendar—featuring a photograph of a gorgeous river scene accompanied by a lofty quotation. A few years back the picture showed the upper Rio Grande somewhere in the San Luis Valley—maybe northern New Mexico, maybe southern Colorado. The photograph was riveting: the river and the mountain caught at the transcendental moment of dawn, with the early morning light touching the distant horizon and reflecting richly in the glass-smooth water. The accompanying quote was from Emerson, something about how contact with nature is contact with untouched creation itself. Taken together, the picture and the language are an earnest river-lover's metaphor for the actual dawn of creation.

▼FAIRY RING, SANTA CRUZ
MOUNTAINS

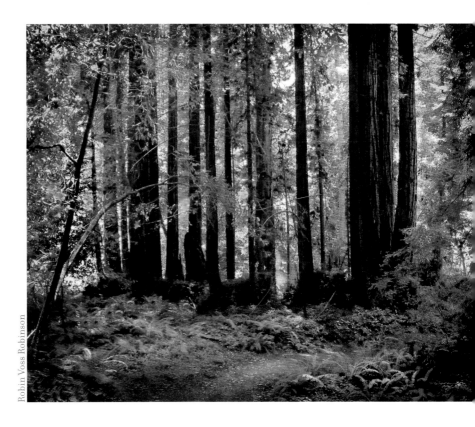

Robin Voss Robinson

But photographs can be uncomfortably literal, and in this case the section of the Rio Grande photographed has been grazed by livestock to a fare-thee-well—and it showed. Close examination into the shadows of the picture reveals all the classic signs of serious overgrazing—woody vegetation gone, banks eroding, the river wide, shallow, and featureless. The seemingly pristine scene was really pretty beat up. If it was the dawn of creation, it was a day or two after God made cows.

A central problem in the West is that scenic beauty doesn't tell us much. Scenic views tell us next to nothing about our success or failure at living within the limits of our ecosystems. I learned only gradually in my conservation work that I did not necessarily know a healthy landscape when I saw one, and I am not the only one. Virtually none of us knows a healthy landscape when we see it. How could we—we did not inherit a healthy West to inform our vision. We have never seen the thing we cherish, although we may think we have.

Yes, the West is beautiful, but beauty is a flawed guide. And an uneven guide, too. Our failure to see can be harder for us to recognize in some kinds of natural scenes, easier in others. I would not expect a forest conservation group to inadvertently put a picture of "Dawn over a Young Tree Farm" on the cover of its calendar, but I think the analogous action could happen easily enough with grasslands, estuaries, or any other places where our alterations of the West have been so complete that nobody (but nobody) knows what they used to look like. Maybe even fairy rings.

Because our relationship with the land is so dominated by vision, and because we do not generally have visions of healthy wild landscapes, it is difficult for us to judge the health or illness of our own country. We are poor judges of the very landscape that is our inheritance and our creation. Without mental images of healthy landscapes, we face the certainty—as befell American Rivers—of being unintentionally and unknowingly estranged from things we care very much about.

"It is fitter to take account every moment of the existence of the universe as a new Creation, and all as a revelation proceeding each moment from the Divinity to the mind of the observer," wrote Emerson. We—unknowing and sometime heavy-handed architects—have no choice but to heed his advice, since creation has been continuously renewed since we took charge. We have created not so much a New West as an Incessantly New West.

We heed Emerson's request unaware. The question of creation is tricky, because we do not see the mark of our own hand—we may not know what to look for in the land we love. It is easy to tell that the Chicago River has been

abused, or the Los Angeles River, because we know what engineering looks like. We don't doubt that species go extinct when their habitat is, say, paved. But we are less alert to the missing young cottonwoods in the groves along the streamsides of western Colorado, eaten by elk, eaten by cattle. We don't notice that in a forest of all old trees, there are no young ones, no cottonwoods of the future coming along.

We are co-authors of creation, but, ironically, we do not recognize our authorship. We generally don't even see it—because we don't know it is ours. Our love for nature is genuine, but we can't tell where we end and nature begins. We can't readily tell Our Creation from That Other Creation.

In my walk in the redwood forests of the Santa Cruz Mountains, I may as well be Adam. I look about the Garden, and it is always new. Only on this day and only in this creation can I (or you, or any other Adam) see forests as they are now and will not be again. No ancestor of mine (or yours) saw whole forests of fairy rings, or hillsides of Scotch broom, or cheatgrass prairies. My grandmother in fact did speak to me of forests, but she could not have spoken to me of the forests through which I walk.

We are the creators of an irreversibly changing landscape, and in our creation, unlike in the other, one generation cannot tell the next what the world is like. In our irreversibly changing landscape, each generation must newly discover how to see and what is to be seen, and that awareness can be discomforting. In my walk in the woods, it gradually dawns on me that my redwood forest will neither persist nor recur.

I cannot tell my grandchildren what the world is like, or will be like. I can tell my grandchildren only that "once upon a time it was like this," and with that or without it, they will have to see for themselves. This is, perhaps, not the worst thing to have to tell them.

SCARIFIED STUMP

∾

*Close examination
of a stump, in all its
philosophical and
biopolitical splendor.*

Many national parks shelter "in-holdings"—parcels of privately owned land and houses that predate the park and are completely surrounded by it. To protect some such in-holdings from so-called catastrophic fire, the Park Service in Rocky Mountain National Park has logged hundreds of trees off public land on the forested moraine immediately uphill and presumably upwind of the half-dozen private houses built along the edge of the valley before the park was established in 1915.

To minimize the unsightly aspects of the logging or to keep the political heat down, or perhaps for other reasons, the Park Service cut the stumps nearly flush with the ground and then scarified the cut surfaces with chain saws to accelerate rot. It appears that occasionally they sprinkled pine needles on stumps to hide them, or rubbed them with dirt, but that might just be wind or coincidence. Since "stump" is such a loaded word in a national park, I wouldn't be surprised at anything, and I do sympathize—these problems are not easy.

The Park Service has done a substantial amount of controlled burning in the neighborhood of these stumps—and elsewhere—as part of an effort to counteract years of fire suppression and with the same goal as the logging: to reduce catastrophic fire. Controlled burning is generally less controversial than logging—unless the fire gets away, as happened in Los Alamos recently. Nevertheless, all land management exposes underlying biopolitical assumptions. The prime theories lodged in the sheared stumps include the beliefs that:

▸ **STUMP, ROCKY MOUNTAIN NATIONAL PARK**

(1) wildfires can be controlled by logging; (2) in-holders' legal claims about Park Service negligence can be controlled by logging; (3) public

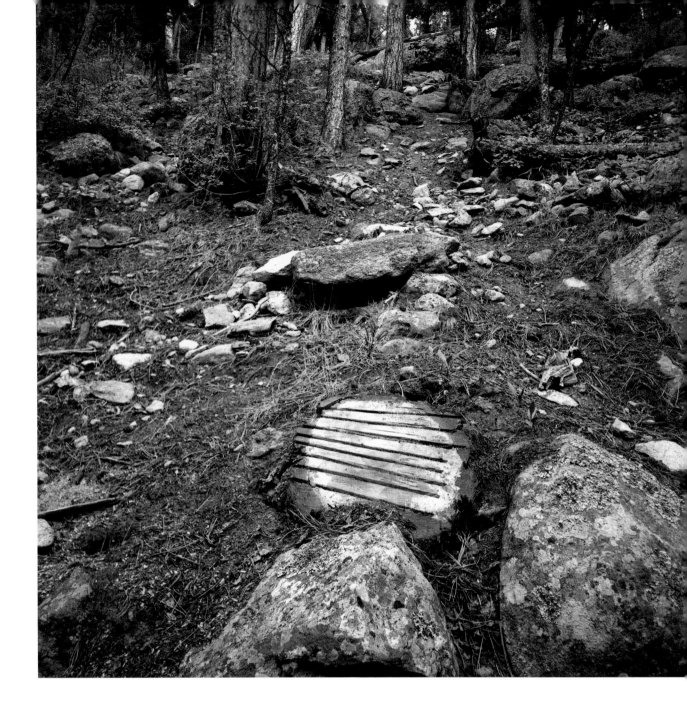

property can and should be manipulated to protect private property;

(4) private property is a meaningful and/or tractable concept;

(5) nature should look natural.

Sir Lawrence Olivier was reputed to have said that acting was a wonderful profession as long as you didn't get caught doing it. Making nature look natural may be similar.

THE RECEDING HORIZON

◞

The hallowed West and the curious absence of western culture.

One would hope that the American West of today would be as far as humans ever get in trying to make geography irrelevant, but it may not be. Astonishingly, there remain some obvious and alarmingly probable avenues of action that would lead to an even stranger and less well-tethered West than today's. Consider, for example, that the cheap federal water that irrigates thousands of acres of low value crops like alfalfa could be reallocated to yet unimagined suburbs—enabling otherwise untenable paroxysms of sprawl for which a more natural infrastructure does not exist. Doing so would defer the reckoning environmentalists always say is coming for a couple of decades, maybe more, and probably add to the abruptness of the reckoning, if and when it comes.

But reckonings don't come easy. I, and my environmental colleagues, have been conspicuously wrong for quite a while in our predictions, for example, that this or that unrenewable resource will *soon* run out. (On the other hand, we have been conspicuously right in predicting widespread species extinction, and local extirpation—the worst in perhaps 100 million years.) But maybe the resources won't run out. Maybe we can continue for some time to rearrange the deck chairs and asymptomatically create western habitations even more ill-fitted to their incomparable settings than what we have today. It seems to me we are already trying pretty hard, but who knows how far things can go. The limits of excess are hard to predict.

There's a widely held current view that the people of the Old West (and their descendants) were close to the land. According to this thinking, new westerners don't get it, and don't, for example, appreciate where their food comes from (as though it comes from the West). In this telling, people of the

Old West depended on and presumably were guided by the land, while people of the New West don't know they depend on the land, and are alienated or divorced or maybe simply unaware of it. There is in all of this more than a whiff of the implication that the Old West, being closer to the land, was also therefore in some way in harmony with it. This thinking ought to raise a snicker. Nineteenth-century western landscape photographs are not unbiased, but at least they are unblinking. They routinely depict remarkably raw scenes in which our old western hand on the land is obviously and alarmingly rough.

Preciousness about the land is relatively recent. Some of today's cherished places were trashed in the nineteenth century (which precipitated the preciousness, of course; it didn't come out of clear sky). Places currently regarded as so fragile that straying off the trails are prohibited—Point Lobos, for example—were grazed, logged, and mined, and even hosted railroads in the nineteenth century, some in the twentieth. The now seemingly pristine meadows of Rocky Mountain National Park were populated not with elk in the nineteenth century but with hotels, horse corrals, and even golf courses. Yosemite still is.

Even those horse-sized elk are manifestations of ironic biopolitics: the native elk of Rocky Mountain National Park and its surrounds were hunted to extinction early on. The elk in the park today are not natives but the descendants of a herd imported from Yellowstone country. There are Euro-American families in the town of Estes Park that have had tenure on site longer than the elk.

Our gradually growing recognition of our heavy hand on the land only addressed the extremes, but that needed doing. Routine nineteenth- and early-twentieth-century logging, grazing, mining, and hunting practices were so scandalous that even not very conservation-minded Congresses passed restrictive legislation to curb the worst excesses.

While ignorance of, or isolation from, the land may have increased as the Old West became new, outright brutishness declined. In a curious and continuing comment on what kind of people we are, while the Old West was more obviously dependent on natural resources than the new, it was also more profligate in their use. Dependence, it seems, does not foster wise use, at least in folks like us. Failure to deal meaningfully with natural resource dependence may be an element in our true, persistent Euro-American character—it seems unchanging (think: oil).

We who inhabit the New West, if there is such a thing, may have lessened our dependence on natural resources relative to our forebears, but in doing

so somehow the net distance from us to nature hasn't much changed. We are no more nor less a part of nature than we were in the nineteenth century, though, yes, some things have changed, and yes, people probably do not know where their food comes from. I look around often enough, I think, and I am not sure I see where the Old West ended and the New West began.

The West, in all its inherent power, has astonishingly not produced an inherently western culture. Instead, an existing American culture was imposed on the West wholesale, despite an obvious incongruity between people and place, and in the face of a natural environment that was, if not hostile, at least demanding and distinctive. But we dug in, and the reports of that thunderclap echo off the canyon walls to this day. As we populated the West, we remained true to who we were, not to the land we inhabited, occupied, and conquered.

The willful culture we brought West was not unified (like we imagine of Japan or Sweden) but was and is Babel, thoroughly fragmented then and now—something that perhaps ought not to be called a culture at all. The change we worked on the land was profound, but yet another irony in the true story of the West (a story shot through with ironies) is the small degree of change the West worked on us.

In the end there may be nothing particularly western about us, the children of the West. We were and are a creative, capable, willful, opportunistic, mobile, cherry-picking, subsidized, development-oriented culture, seamlessly at one with our brethren in the East and Midwest and, maybe especially, the South. We westerners are Americans through and through, and always were.

This only stands to reason. Culture takes time to develop, and we never gave it time. There was no gestation period for us in the West, and no infancy—we did not grow up here, so to speak. We came to the West full grown, just as we had everywhere else. We didn't give the landscape much of a headstart. It is perhaps those who feel at home in the West that have some explaining to do.

As the days lengthened, we found ourselves (somewhat to our surprise) in a landscape sufficiently compelling that we had to stop and stare, at least for a while. But that may have been about all we did differently. We saw that the West was new, but we acted the same as we ever did. There may be a distinctly western attitude toward scenery, but ironically there is little or no western attitude toward the West. Our culture-without-roots persists with its internal chaos, never closing much on the gap between us and the landscape. We continue to move toward the horizon—but the horizon continues to recede.

► "LAKE" BILLY CHINOOK, CENTRAL OREGON

FIELD NOTES FROM BABEL

〜

*A fragmented culture
and the landscape
that confers no unity.*

From near the abandoned town of Cisco, Utah, a circuitous two-lane highway closely tracks the Colorado River fifty miles or so downriver to Moab. I drove the familiar road one spring day recently enough, on a fool's errand: looking for The True West in the unparalleled succession of exquisite empty spaces. Obviously I didn't find it. More important, the illusion of emptiness didn't last; it steadily devolved into awareness of a country somehow fully occupied by very few actual people.

But passersby have carved their marks, pictures, names, and signs on the rocks along this river, their scratchings persisting indefinitely in the dry air. Signs overlap on some rocks, sit adjacent on others, and are fully separate elsewhere, just like the folks that produced them. One carved bird, I notice, is particularly nice.

I knew perfectly well that looking for the West was a poor idea, but I thought this might be the right place to look for it anyway. The incised red-rock canyons of these middle stretches of the Colorado River and its tributaries are about as deep into the West as you can go. Nowhere, not even the most cowboy parts of Wyoming, are farther West, metaphorically speaking, than canyon country—and it has been for all of Euro-American western history, from the Crossing of the Fathers to the Crossing of I-70. The camera sat beside me on the car seat.

Then as now, I wondered: Is the West a place? How do you know when you are there? Does the West have a heart, a center, a middle? It clearly has edges. If you approach from the east, there is no question when you hit the mountains (indeed, when you see them) that you are rising from the plains. Similarly, if less decisively, as you go north from anywhere in the West, sooner or

later you get to what is clearly north country, country where the forests are dark and where winter is never far away. As you go south, you enter Mexico, usually well before the legal boundary. It is only the western edge of the West that is peculiar—as many have pointed out. Is California in the West? Edward Weston parsed the question by confidently titling one of his major works "California and the West." I'll go with Weston—I think not.

If the West is anything, it is not part of a continuum. It is rather one pole of a dichotomy: West and not West. And once you are in the West, you can't go farther. There is, for example, no place farther West than Rifle, Colorado, or Burns, Oregon, or Missoula or Pocatello or Lone Pine or Rock Springs and a host of other places. The West appears to be a condition or an attribute, since it doesn't come in degrees. I will leave it to the topologists and logicians to tell us what kind of place has four (or possibly three) sides, and no middle.

As I drove, I had a photographic destination in mind, the confluence of the Dolores River and the Colorado. In this out-of-the-way place, two ancient, silt-laden rivers join their separate five-million-year efforts to quarry down the whole red-rock Colorado plateau and carry it to the sea, grain by grain—the same endless work as was done by the sparrow in the Middle Eastern myth. Geologic time and time of day don't seem much different in a place like this—echoes of infinity and all that. I found the confluence, parked the car, climbed half the hill behind the road, and made the photograph. A fair portion of the entire West is upstream and uphill from here. Just below the actual confluence was a ranch that was raising llamas. Next it will probably be yaks. Okay, maybe there is a New West.

I passed the remnants of the tiny abandoned town of Cisco, recently and incomprehensibly papered with prematurely wind-whipped flyers, entreating anyone who might read them to "Bring back the 10 commandments!" or "Say no to crack!" Frankly, unlike the citizens, the commandments seem never to have left Cisco, and crack seems never to have arrived, so someone was being extraordinarily righteous in their pamphleteering, considering the setting. With no one to shoulder the burden, Cisco seemed weighed down by sincerity.

It was that day on the road downstream from Cisco that I began to think that the West isn't really a place. In some science fiction a marvelously complex being, thoughts and all, is reconstructed from a tiny sliver of bone—as though each fragment contains not just the essence of the whole but the fine detail. Maybe Moab is the sliver of bone.

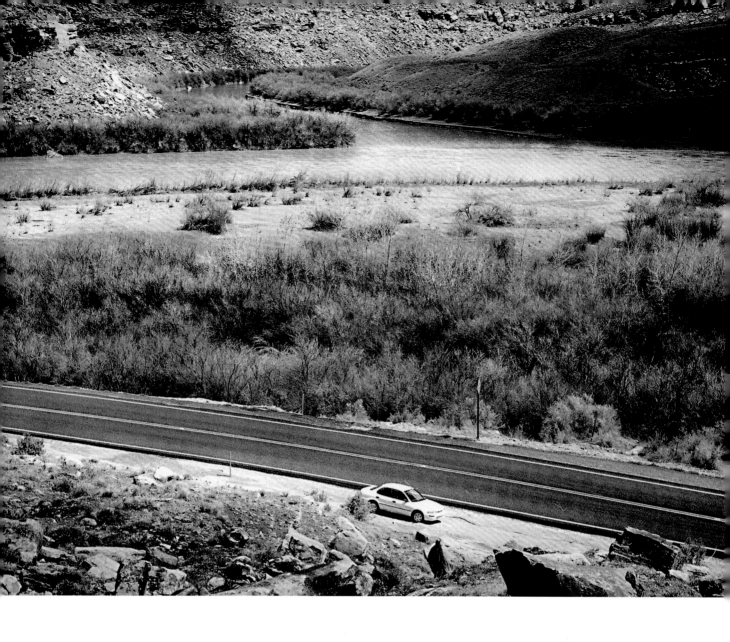

If the West were a product of its natural environment, then Moab would be the center of the West. It lies in the shadow of the enormous Moab fault and at the center of, arguably, the greatest system of canyons on earth. It is drier than the Gobi. It houses the downstream end of an unbroken succession of desert plant communities that replace one another uphill and upstream, starting at riparian thickets along the Colorado River and ending at the tundra on the summits of the La Sal Mountains, two vertical miles above. But despite the seemingly compelling physical setting, Moab is not particularly characterized by faults or ecosystems, plant communities, or ironically even by its canyons. Beyond the obvious, Moab does not seem all that significantly defined by natural forces of any sort despite tangible presence in all directions of all of them.

Moab is a good case of the West—you probably can't name a better one—but to understand it, you don't have to know much about the West, you have to know about us. Moab is defined by culture, not nature, or more precisely a fragmented culture whose parts are more closely tied to roots elsewhere in the state, region, nation, and world than to anything local.

You can tour the entire West in a walk around Moab, taking in the solidly middle-class City Market (hesitantly embracing organic vegetables), the espresso stand in front of Rim Cyclery, the funky natural food store, the truck stop, and Les Schwab Tires—a cultural crossroads of a sort, since, in the West, everybody needs tires.

Moab is small enough that the fragments that make the West the West are practically adjacent physically, however far apart they are culturally. Moab exhibits everything that makes the West the West, notably the cultural fault lines that keep the disparate pieces of American culture from fitting together.

There is not one Moab (or West or America), and not two, but many. The retired uranium miners, the Mormon families, the refugees from Boston and Boulder and Salt Lake, the truckers, the ranch owners and their cowboys, the rafters, mountain bikers, and Harley riders, the self-consciously hip, the middle-class functionaries that make our society work, all know they are a piece of the West, all know that the West is made of pieces, and all know (although they might not say it) that the pieces don't quite fit. In the West, we know who we are, and we know what we are not: any of us can tell at a glance that a Frenchman in a cowboy outfit is not a real cowboy.

We are the West, not the reverse. While we live in the presence of a powerful landscape, and arguably we are here *because* of a powerful landscape,

◄ RENTAL CAR AT THE CON-
FLUENCE OF THE DOLORES
AND THE COLORADO RIVERS,
EAST OF MOAB, UTAH

evidently this landscape is not powerful enough to substantially shape our culture. The real geography of the Euro-American West is not spatial and physical but conceptual and cultural: even in the shadow of a great fault, we are not the products of our land.

We never tried to be, and necessity or poverty never forced us. In the American West, the social environment strongly trumps the natural, even when the natural environment is both compelling, venerated, and well noted.

<center>⌒</center>

Each of us who lives in the West has a tangle of thoughts/ideas/images/ feelings in our heads that delineates the whereabouts of everything worthy of note in the West—a map, so to speak. Technically speaking, the larger West is the intersection of all our maps, the degree to which our pictures of reality are congruent. The real West is no more and no less than whatever we all have in common. There is, ironically, no point in seeking the West in the West.

And as far as the natural world is concerned, there is not much that we have in common. Everybody's map includes some natural elements, from the banal (rain, for example) to, say, the Grand Canyon, but the degree of detail about nature necessary to negotiate your way in the West is vanishingly small. In the Old West, nature occupied more of the map, but even where the raw materials of nature are concerned, the maps differ: some people have mentally painted in the missing willows along the stream in the Lamar Valley; most haven't.

Our orientation is more to each other than to the world, and our interactions with the natural world are trivial compared with the intricate geography of family, friends, and human hubbub that defines our lives. We know where we are by who we are.

My fellow travelers—and probably yours—are not my proximate neighbors. My compatriots share enough sociological, economic, political, moral, intellectual, and esthetic space that we are glued together, creating the illusion that we are not alone. In a society so remarkably ungeographical, each of us is a member of a suite of noncontiguous cultural fragments. Yes, proximity counts, but physical closeness is not the issue it would be if the West were more a physical place, or if people stayed put.

Physically we live side-by-side and share the literal West; culturally we live in communities of the mind and create the real West, the one we have invented, which is to say that the literal or physical West is not the real West.

Culture can be thought of as the sum of shared experience, the overlap of all things taken for granted. Our effort to live in the West as though nature didn't matter is so successful that nature is not much a part of our culture, despite a complex suite of shared notions about the picturesque. We have used our unequalled power and creativity in part to so thoroughly insulate ourselves from nature that we don't have much experience with it. Learning to live in harmony with the naturally uneven distribution of water might have defined us, had we been very different people, but it did not and does not.

You would think the overwhelming physical environment would have unified the culture or forced the creation of a new one. You would think that shared experience of the natural world would be the West's revered centerpiece—shared meanings in the landscape and shared experiences of it—in a word, culture. Look around Moab, or anywhere else, and ask yourself how much of the ecological and physical reality of the West is on its way to being meaningfully imbedded in a western culture. Not much.

The exception is the scenic climax. We have enough unity to respect sheer visual drama, if not the subtlety and biological richness of our lamented and beautiful West. We have made trails and roads all over the West to carry us to the big views: Inspiration Point, Artist's Point, Dead Horse Point, Zabriskie Point. As it happens, one of those roads pointed Ansel Adams to the site of his astonishingly romantic and dramatic picture of a great thunderstorm over the Tetons. Fifty years to the day (as best we could figure) after he made the classic view, my friend DJ Bassett and I went to look for the place where Ansel had set up his big camera. The spot was so easy to find that our expedition was ridiculous. There is a paved pullout at the site and a full-scale overlook, lacking only a diagram of the great photo. More than a few of the great photographs have been made from already existing scenic pullouts, as though the function of the great landscape image is to confirm the view held in common so completely that the route to it is already paved.

Euro-Americans have explicitly agreed, as a society and as a matter of both culture and law, that views of some western landscapes are a common good that cannot and should not be owned, and should be passed down unimpaired to future generations (to paraphrase the language of the charter of Yellowstone Park). We continue to act on that agreement: the roads in national parks are laid out so that they lead to big views. (By way of explicit contrast, the roads in national forests lead to resource development sites: logging areas, mines, and so on.)

Perhaps respect for the scenery is the seed of an eventual western culture, but if so, culture seems a long way off. Reverence for the scenery is not going to be enough to develop a wise and insightful shared relationship with a landscape—a culture worthy of its landscape. To an astonishing degree, the landscape of the West (fabled West, storied West, venerated, filmed, sung, written West) is not yet all that meaningful to us.

We were and are the kind of folks who are easily (if perhaps not all that deeply) divided into fragments by class, religion, education, wealth, mobility, expectation, age, race, gender, and outlook, and more. The landscape does not unify us.

The wind-whipped flyers at Cisco, the unblinking llamas, the carved bird weathering in the sun, the espresso stand, and the tire shop are each center-points of alternative Wests whose overlap is neither so extensive nor well understood to assure mutual gravitation across a shared landscape. Instead, from any point in the West (and probably from any point anywhere) the remainder of the universe pulls away equally and in all directions.

I had been looking for the West's heart of hearts, but all I found was Babel—and an indisputable feeling that there is more talking than understanding. I had known all along that a search for the West was a fool's errand, but only gradually did I come to see the face of my blindness. Anywhere I looked I found a West partly like Einstein might have envisioned: a relativistic West—where nothing is fixed, everything is in motion, and no motion absolute. No matter where you stand, no matter which way you look, everything is receding, from you, from Moab, from anywhere. You are already at the center of the West.

SCANNING FOR WOLVES

Enough large and obvious wild animals populate the Lamar Valley of the Yellowstone in late September that you soon begin, unconsciously, to scan the landscape for them: elk, bison, pronghorn, moose, mule deer, bighorn sheep, a local breed of coyotes so regal as to make you think other coyotes are some different animal, and always, at least the chance of wolf or bear.

The landscape always shapes us, and sometimes we notice.

For a time the animals take you by surprise. Suddenly under the trees (over the rise, around the bend, out of the corner of your eye) you see, say, a moose—a huge and unbelievably muscular purple-gray shape at the edge of the snow.

Rapidly your seeing sharpens. You start to develop an alertness for animals you did not have before, and a feedback loop takes hold: you scan more skillfully for the next critter, find one, and begin to scan better yet. The landscape is reshaping you.

The most addictive reward schemes are those in which both the timing and the amount of the payoff are random—where the prize may come at any time and in any size, and where timing and size are independent and unpredictable. Slot machine designers doubtless have the most refined understanding of the calibration of this process—you can hit the big time anytime—but the Lamar Valley provides animal sighting jackpots often enough and large enough to turn a percentage of Yellowstone tourists into addicts.

In scanning the Lamar Valley for large animals, the payoff is frequently elk or bison; deer are fewer than you would think. One day the reward is the unearthly clatter of sandhill cranes high overhead. Another day a pronghorn is freshly down, and there is blood in the snow.

The addiction is strong enough that since 1995 wolf followers have patrolled the road from Mammoth to Cooke City, armed with small telescopes and large binoculars (and even an antenna or two, to track the radio-collared members of the packs). Ad hoc theories about wolf movements circulate continuously.

Wolves have become the drug of choice for addicts of whatever it is the Lamar Valley has at its core. Wolves are fast-trotting evidence that something is not yet altogether lost, not quite gone, not here, anyway: their iconic value is very high. In addition they are perhaps less unpredictable than bears, and you need take no risks to see them. Bears still outrank wolves, but not by much.

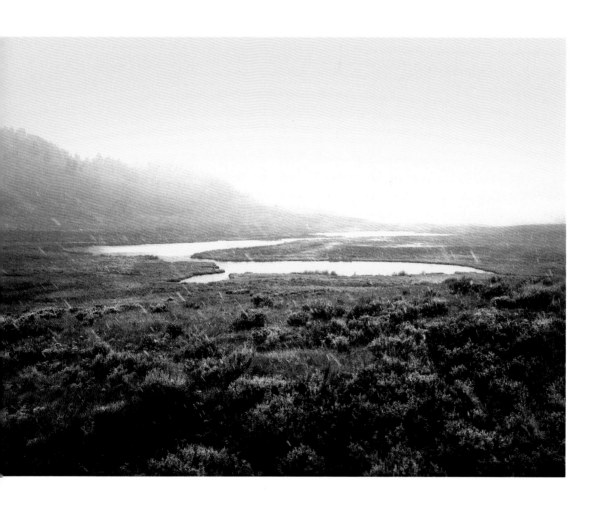

If you scan the valley for long, you will eventually see the wolves. Perhaps, better yet, you will hear them. The voice of a single wolf, carried on the wind while you watch bison herding up in the fall's first snowflakes, is an essence of wildness so concentrated that when you tell others about it, you will hardly sound credible.

After the third or fourth day in the Lamar Valley, your scanner is simply on alert all the time, turned up high early and late in the day or at any blind spot on the trail, but on all day regardless. Who you are is being noticeably shaped by where you are. Perhaps who we are is *always* shaped by where we are, only without it being so pleasant and obvious as in the Lamar Valley with winter never far away. (The last time I went for a hike in the Lamar—a stroll really—it was summer when I left the trailhead, and winter when I returned.)

This newfound ability to see develops and improves but it never quite becomes automatic—it is not like breathing. In the Lamar Valley it becomes obvious that your seeing is not a faculty of yours (as is usually assumed), but rather an aspect of the fit between you and the world.

Seeing, seemingly the most objective act, is not internal, not passive; it is not a given. It is an active manifestation of how-the-world-works, and what-peace-have-you-made-with-it and what-does-it-all-mean and what-is-life-all-about and just-exactly-how-do-you-live-it. Seeing is existence, no more, no less. How we exist is shaped in part by how we see, and how we see is shaped in part by what there is to see. That in turn is shaped by what we as a society and as individuals do and think, and by what we care about. There is no real boundary between seeing and knowing, and in the Lamar Valley, in coming to see where the animals are, you come to know where you are.

One consequence of knowing where you are is knowing when you leave. Having rewarded you with jackpots, your scanner will still be turned on when you leave Yellowstone. Very abruptly, indeed right at the border of the park, your scanner—still turned on high, still trained at the fringe of trees at the edge of the meadow—suddenly picks up only cows. Cows. And more cows. A moose now and then; deer, of course. A bison, looking absurdly large as it crosses a parking lot. But mostly cows.

Boundaries are typically more real on the map than they are on the ground, but not always so. Some boundaries are real enough that as you cross them you can feel the choices we have made about the West in your body. Some boundaries are real enough that what changes as you cross them is you.

◄ FIRST DAY OF SUMMER,
BLACKTAIL PONDS,
YELLOWSTONE NATIONAL PARK

THE NEW WEST, THE OLD WEST,
AND THE POTATO

❧

. . . but not just the potato. In the true economy of the West, the many subsidize the few.

It is hard to think of a better symbol of the West, or of the West's surreal relationship with the federal government and the so-called free market, than the Idaho potato.

While the potato is a great symbol, it is not a perfect one: it lacks the iconic status of the buffalo, the eagle, or the Marlboro Man. What's worse, the potato is not a certified piece of Americana as is, for example, the cheeseburger. But the great chain-of-being links cheeseburgers and fries, potatoes and Idaho, so inseparably that knowledge of Idaho and its potatoes seems central to knowledge of western American archetypes, and, it turns out, the western economy as well. And without question, taking Idaho seriously is a challenge central to any understanding of the West. Idaho's immortal license plate slogan is "Famous Potatoes," but I sometimes think Idaho and its potatoes are best understood as the West's Heart of Darkness: "Going up to Idaho is like going back in time . . ."

A number of years ago I was in a fairly rough and tumble conservation battle that involved the State of Idaho. One day, the governor's natural resources aide was on the phone with me—telling me, among other things, that I didn't understand Idaho.

I didn't understand, he said, that Idaho's environment was the best in the West because Idaho was the last part of the West to be settled and was thereby spared the excesses of logging and grazing that scarred so many other places in the West's early days. Remember, he said, Idaho was spared because it was the last of the forty-eight states admitted to the Union (a classic error of local pride: in the West, Idaho was followed by Wyoming, Utah, Nevada, New Mexico, and Arizona). Things are good here, he said, they've always been

good here, and we don't need any federal bureaucrats or environmentalists like you running around trying to make problems.

In reality Idaho wasn't spared anything and is no better or worse than any other part of the West. People occasionally strain when they try to define themselves, and someone should make a collection of Western slogans that try too hard, starting perhaps with "It's happening in Soledad." Such a collection unfortunately can't include that of the incomparable Winnemucca, Nevada, whose edge-of-town welcome sign says: "If you won't stop, who will?"

Which brings me back to the potato. From its earthy start in the dark volcanic soils of the Snake River plains to its demise at, say, a McDonald's on Sepulveda Boulevard in Los Angeles, the potato perfectly captures the seldom admitted but highly and delightfully socialist economy of the real West, new and old.

The West, from the beginning of Euro-American occupation, can be fairly understood as the product of local opportunistic exploitation of successive waves of massive, federally financed development ventures: the expeditions of Lewis and Clark, Fremont, Pike, Long, Hayden, and others; the army; the railroads; several waves of water projects; electrification; interstate highways; and (beginning with WWII) a defense buildup critically important to California, Utah, and Washington. American taxpayers funded the development of the West's infrastructure, and local interests, naturally enough, found ways to capitalize on those investments in an unending succession of the many supporting the few. Potato growers, while an excellent example of this phenomenon, are no better or worse than other westerners: we are all equally the beneficiaries of really enormous federal government spending.

So at last the potato: lots of those famous potatoes are irrigated with water from taxpayer-subsidized federal water projects (water pumped with electric power from the taxpayer-subsidized Bonneville Power Administration) and delivered to distant markets over the taxpayer-financed interstate highway system in trucks powered by artificially cheap fuel—whose pump prices don't begin to reflect what taxpayers spend protecting private oil interests all over the world. When you order fries at McDonald's, an excellent argument can be made that you have already paid for them.

Both the idea and the reality of the Bonneville Power Administration require an aside: it was a project so clearly socialistic that the BPA actually hired fellow traveler Woody Guthrie to write "folk" songs commemorating the workers and the dams they built. This hiring ricochets off in several surreal directions—not the least of which is: if they are folk songs, how can you hire

somebody to write them? Nevertheless, the Columbia rolls on. The Columbia River hydropower delivered to citizens of the Northwest is underwritten by federal taxes to this day (a subsidy that is ardently defended by free market Northwest members of Congress) and is thereby substantially cheaper than power elsewhere in the country, except the equally subsidized power from the Tennessee Valley Authority. Northwest aluminum companies, and the airplane builders that use their cheap aluminum, should be especially grateful, but I expect you haven't gotten a thank-you card. The formula for building, say, airplanes, using the might of the Columbia River is all-American in its simplicity: socialize the costs, and privatize the profits. As I am writing this, a group of farmers in Arkansas is actively courting Congress for such support, using the explicit argument that the feds underwrote the West for years, and it's time to do it for Arkansas. And, in an increasing arc of incongruity, in calculating the so-called costs of "saving" Columbia River salmon, the imagined revenue of electrical production supposedly forgone as a result of leaving water in the river for fish is debited to the fish restoration account, which means two things: (1) the apparent cost of saving salmon is padded by hundreds of millions of imaginary dollars yearly, and (2) the fish are, ironically, the only large user of electricity who pay retail.

If one of the constitutional functions of government is to "promote the general welfare"—a founding father's phrase so delightfully leftist that I assume it makes full-moon right-wing talk-show hosts queasy—then in the West government is a dazzling success. When western governors, senators, members of Congress, county commissioners, mayors (whatever), predictably complain about excessive federal government, I always listen, with hope, for howls of laughter. They never come.

In fairness, it may not be particularly appropriate to single out Idaho or its famous potatoes as the target of this argument, except to make the political ironies vivid. Other crops are equally suspect: the low-priced alfalfa grown with the fabulously expensive water from the Central Arizona Project, for example. And perhaps the greatest subsidies don't go to crops at all but to some other form of enterprise entirely. Maybe mining, whose practitioners can lay claim to public land and pay for it in 1876 prices.

But wherever it ranks, the potato, like much else in the West, is a "privately" produced product whose profitability stands on the shoulders of giant federal investments that are the manifestation of an economic policy continuously sustained from the beginning of Euro-American occupation of the West. In the shadow of such subsidies, the incessant western bad-

mouthing of the federal government would be ill mannered if it weren't so surreal.

Do I seriously think that taxpayers underwrite the profits in Idaho French fries? I seriously do. Eastern, southern, and midwestern taxpayers built the West, down to its potatoes. We should thank them.

Ironically, if there is an Old West and a New West—which I usually doubt—it's almost certainly the ruggedly individualistic and self-reliant Old West that was more federally dependent. The financial presence of the federal government in the West may have peaked in the days when the U.S. Army was keeping the "peace," when land deals were being made with railroads, and the early water projects were being built. Some assiduous researcher should ferret out the numbers, but I am willing to bet that federal subsidies as a percentage of the Euro-American western economy have never been lower than today. You would think that with today's modest federal presence, and with the legacy of profits we leveraged out of federal expenditures, western municipalities would honor the memory of federal largesse reverentially. In every town square in the West there really ought to be a statue of an actual, historic, mid-level federal bureaucrat, say, for example, the deputy assistant undersecretary of agriculture in the Eisenhower administration.

Since federal investment floated the Old West economy, then as federal government subsidy fades, maintaining western Americana—keeping ranchers in business, for example—will require progressively greater non-governmental support. In other words, to preserve the old subsidized West, new underwriters will have to be found. And, astonishingly, conservation groups are stepping forward to do just that—offering to take over ranches' debt to keep them from failing, thereby effectively replacing a benevolent federal government with outright charity. Often the target ranches are in the path of development, and are saved by nongovernmental organizations to prevent them from devolving into ranchettes (or something worse, if there is anything worse)—all this a form of conservation that fights the pressure of money with other money. So, students of western irony take note: the Nature Conservancy (with what is staggering wealth, by conservation standards) is buying western ranches, not to stop grazing but to continue it—an approach characterized as preserving "a working landscape."

There is an implied esthetic both in the notion of a working landscape and in the defense of western ranching. The implication is, I believe, that there was something economically and/or socially and/or environmentally *beautiful* about the West from, say, 1875 to 1975—the century of ranching that

extended from near the end of the cattle drives to the stirrings of the so-called New West. Contemporary grazing acquisitions seem to be informed by a sense of beauty that echoes that century.

Most western ranches don't make any real money today—and never did if you count the taxpayer subsidies, which I do. No one should be surprised if the new advocates for preserving ranching in the New West explicitly start to lobby for perpetuation of traditional subsidies—low public-land grazing fees, for example.

I suspect that in every other culture in the world the people who raise generic commodities (cows or potatoes, for example) in more remote and less inherently productive regions (Idaho, for example) are a poverty-stricken class. I don't think there is a place in the world where you can get rich raising a standard crop under inhospitable conditions, except, apparently, in the government-loathing place self-styled as the last-touched part of the Union.

Federal spending and the economy of the West are, in fact, inseparable, and they have been since at least Lewis and Clark (who had express orders from Jefferson to assess the business potential of the region). No part of the country is more socialized, and no region more bemoans the federal presence. Even on the short list of western ironies, you pretty much have to save room for the potato.

THE COW SHIVA,
DESTROYER OF WORLDS

I made a tongue-in-cheek photograph of a cow on my way out of Moab one day: a cow blocking the road and the view, staring at me, me staring back. She, descended from the forests of rural Borneo; me, descended from the churches of rural Britain—two ex-patriots eyeing each other against a heart-stopping background of red-rock canyon walls and the La Sal Mountains. We are each of us in a newfound land, and neither I nor she is yet well-fitted to this landscape. She, at least, is color-coordinated and blends in pretty well at a distance.

While cow politics are always on my mind in cow country, I did not mean to make an overtly political picture. I was just hoping for a classic snapshot: the landscape-colored cow was on the road, the camera was at hand, the light was soft and revealing. I snapped the picture out the car window as I rolled slowly by.

Making the snapshot set me thinking about The Western Cow, although equally I could have considered The Western Landscape or perhaps most appropriately, The Western Photographer, His Hand on the Wheel. But on this most unusual gray morning my rumination was on the western cow: the iconic cow, the cow pawn in public land debates, the color-coordinated cow blotting out the mesa.

And mostly (given my predilections) my thoughts focused on the cow Shiva, Destroyer of Worlds. I imagined this landscape, which rises

In which the seeker encounters a steer, a national park employee, and the shared landscape.

▼ THE COW SHIVA, IN OR NEAR CANYONLANDS NATIONAL PARK

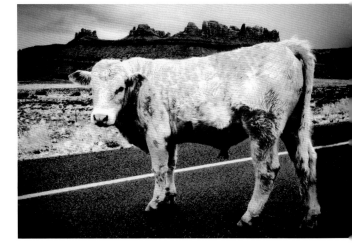

above other landscapes, in its lost beauty before cows, and I visualized it without cows stretching off indefinitely into its future. I tried to conjure the landscape without us, but with them, and vice-versa—it was a jumbled succession of cow thoughts, neither difficult nor original, but centered obviously on the hoped-for demise of the ubiquitous and domesticated cow of the West.

For those not versed in such matters, the word "cow" properly refers only to adult female cattle. It is frequently if incorrectly used to refer to steers (emasculated males) and even intact bulls, as in the phrase "look at that bunch of cows." Properly, this entry should be titled, "The Steer Shiva, Destroyer of Worlds," but that is too graceless to merit serious consideration. Suffice it to say that it is the steer shiva depicted above, whatever the title.

Arguably, the cow is Euro-America's greatest agent of destruction where the biological integrity of western landscapes is concerned. Road building is the only close competitor. Logging, mining, suburban development, and routine pollution are followers. Many more acres of public land—many, many more—are grazed than are logged. And most of what is logged is also grazed. The domesticated cow may not be the destroyer of worlds, but it is a reasonable candidate.

It began to rain as I drove. Rain, needless to say, is an extraordinary thing in a land drier than the Gobi, and a sheen of water made an already otherworldly scene indescribably beautiful.

Wrapped in the silence of beauty (and done thinking about cows for now), I stopped at an isolated entrance to Canyonlands National Park, paying the fee to a grandmotherly attendant. It was a lonely morning, and civility demanded that I try to make a little conversation. "Nice rainstorm," I offered. "It sure is," she replied, "The cows were about to blow away if they didn't get some moisture soon."

At 1:30 in the afternoon of March 4, 1907, eleven months after the Great Earthquake, a nameless traveler mailed a postcard from San Francisco to a Master Allan H. Southard, of Manchester, New Hampshire. Because postal regulations at the time prohibited the use of the back of a postcard for messages, senders became skilled in composing cryptic missives to fit the sometimes limited front space available. Even by those standards, this card is a masterpiece of the succinct (if not the transparent), and the astonishing photograph is so ripe with incongruities that even the enigmatic handwritten text—"the last one for a while"—seems only in keeping.

The last what for a while, one wonders? The last big fir? You would have thought that in 1907 the stock of large fir would have seemed endless (we certainly acted as though it was endless). But perhaps not. By 1907 efforts had been underway for some time to preserve California old growth: by then a forest reserve at Muir Woods was already established, and the Sempervirens Fund had had its first success in setting aside a fraction of the huge trees near Santa Cruz. More broadly, by 1907 Yellowstone and Yosemite had been protected for some time, Rocky Mountain Park was being negotiated, and others were in the works.

The year 1907 is actually after the flood, so to speak—logging of the more accessible old growth was already over by the turn of that century: the big blitz was from the gold rush to about 1870. By the time of the postcard, the easy local stuff had been gone for decades, and it is possible to imagine a traveler having passed through heavily logged Seattle, now about to leave San Francisco, writing back to a young man in New Hampshire—which itself had been heavily logged another hundred years before—with a cryptic lament.

A prose poem in which the ephemeral is the permanent.

But it is not likely. Despite the efforts underway even a century ago to pre-serve groves of the big trees, it probably takes a contemporary consciousness to link the text on the card to the fate of the tree, despite their juxtaposition.

More likely, the terse and ambiguous phrase reflects the status of San Francisco as a jumping-off point—to Alaska, to Hawai'i, to the Far East, around the Horn, to the gold country, even back east by train. San Francisco was the last resting place before one began a long haul where post offices became scarce. Likely enough it was the last postcard for a while—a thought-ful gesture from a traveler who knew it would be some time before another card could be mailed to Master Southard.

The precision of a postmark forces us to recall that all that happens, hap-pens at exact times—times we frequently don't know, of course, but exact ones nevertheless. (Our ignorance of the facts should not be confused with imprecision in the world.) In the exact and actual world, trees fall, minds change, cards arrive, and the ground trembles at very particular moments. But, remarkably, there is no symmetry between things that happen and things that do not happen, between things that are done and those left undone.

▼ FOUND POSTCARD

There is no moment when the tree does not fall or the card does not arrive. But on the face of the card, of course, the tree never falls. On the face of the card, at least, it is not the last one for a while, it is the last one forever.

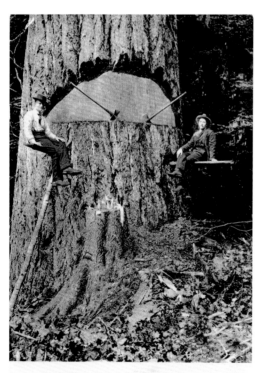

The last one for a while

NOTES ON A SHARED LANDSCAPE

My fundamental relationship to the natural world has centered exclusively on the West since I was about eight years old. For me, it's not about nature; it's about the West and nothing else. Nowhere else—the jungle, the arctic, the great north woods, the Himalaya, the oceans—counted to me when I was eight, and mostly still does not.

It was when I was eight that my family, to my distress, moved away from my Colorado birthright, and I was forced to live for years in the flatlands of Kansas and Texas. My quite conscious reaction was never once to concede to myself or to anyone else that I actually lived in Kansas or Texas. I was a headstrong eight-year-old, and as best I could, I denied everything—and I did that pretty well. To this day, my unwavering feeling is no matter where I live, if it is very far from Boulder, Colorado, I am only visiting.

My Texas schoolmates aided in my isolation by reminding me frequently that I was a "Yankee"—an archly critical term that to my surprise had remarkable currency in Texas a century after the Civil War. My childhood diaspora ended as early as I could manage. At first light on the morning after my high school graduation, I left Texas for Boulder, never to return.

It seems that some of our most compelling works result when the skills of the adult are brought to bear on the feelings of the child. Something important can happen when the absorption of the eight-year-old is sustained despite the desiccating gaze of the adult. Maybe we are at our best when the child meets the man, when thought and memory merge, and common words are found.

For thirty years, I have lived on the same piece of ground in Oregon. Curiously, while it has been thirty years of precisely the same location, it has not

Maybe you still cut the peonies your grandmother planted, but in the West, probably not.

been in the same house. Ten years ago, on a lovely and windless April afternoon, my house in the woods inexplicably burned to the ground. The smoke rose vertically.

My friend Michael Scarola and his associates took about a year to build a new house for me. Its alignment on the property is so similar to that of the old one that the views from inside the rooms have not changed—the heavy forests of Spencer's Butte are still the background to my morning coffee. But nevertheless, looking out the window in the new house was unsettling: the view was the same, but the window had changed. It has taken years for the incongruity of such reframing to subside.

Despite my time in one place, I am still troubled by a feeling I have known since well before I got here: a sense of not entirely belonging. It is possible that thirty years is not enough to soothe such troubles—perhaps generations are required. Perhaps you have to learn from your mother's mother how to live where you live. Maybe those of us who do not have the doubtlessly mixed blessings of living in the shadow of our mother's mother will never quite belong anywhere.

Maybe, on the other hand, I have not paid enough attention, or did not pay attention in formative times, when I needed to acquire the local landscape the way children acquire languages. Or maybe I lack some gift. Maybe some humans have a special skill—the equivalent of being able to carry a tune—that allows them to more easily hear local rhythms. I don't think so. I do not think only the gifted can interconnect with the landscapes that house them. I don't think I am unusual, for better or for worse.

The western landscape has a naturally syncopated rhythm: the thunderclaps come, but rarely on the downbeat. Making sense of the West takes rhythm, no matter how much time is allowed, no matter what the pulse. In the long term, making sense will require some essential fraction of the West's residents to agree on a cadence audible over several human generations, a cadence marked by both the naturally predictable (autumn, for example, or eclipses) and the naturally episodic (fire, Chinook winds, flood).

But no sense will be found if the scene itself is changing, if the valley turns green out of season, if houses sprout after a rain. In that case, the West your grandmother told you about is likely to remain her West, and not yours. Generations of western writers and artists have created passionate personal relationships with the landscape, but the embrace is necessarily solitary and will not survive their passing. The land we live in does not have much in common with that of our grandmothers, nor does what we understand have much

▶ CLEARCUT AND MID-SLOPE
ROAD, DOUGLAS COUNTY,
OREGON

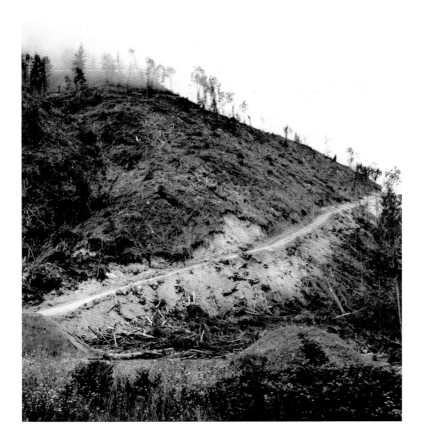

in common with our neighbors. It should not be surprising that a sense of western community eludes us. I can find my path in the West, but footprints ahead of mine are scarce, and my way promises only increasing isolation, leading, as it does, through a land already crisscrossed with isolation.

I am what I think I am: temporary, just visiting. I can't go home—the West of my youth hardly exists. Maybe you are more fortunate, maybe the landscape of your youth persists. Maybe in northern Michigan, maybe in the rural south, your family still airs out the cabin by the lake early each summer, and boards it up each fall. Maybe you still cut the last of the peonies your grandmother planted or are teaching your daughter how to do the same. But in the West, probably not. In the West, it seems none of us have and maybe none of us can have what home needs to be—a place where neither the view nor the window changes. We have created a place where no one is native, where no one has to let you in. I don't know. Sometimes, hunched over my desk, trying to get these words right, I have the feeling that if I glance over my shoulder quickly enough I will catch sight of where I really am.

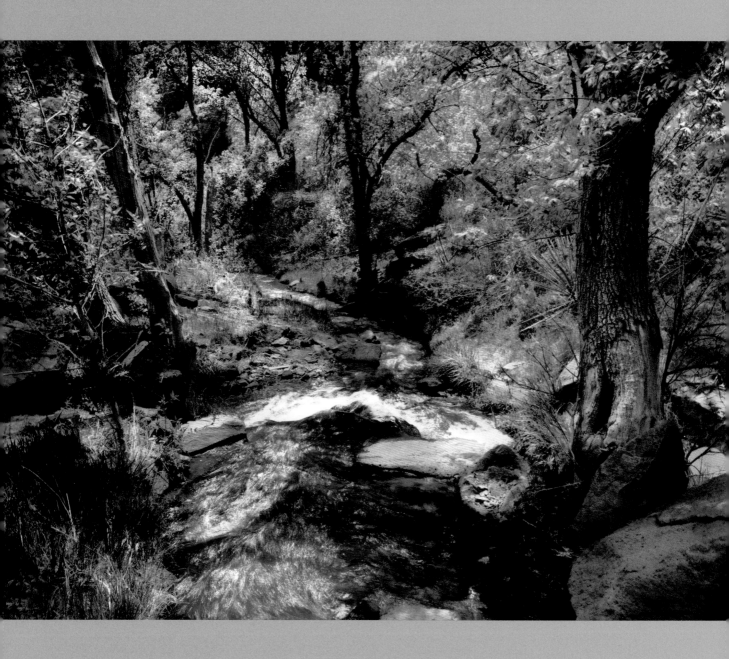

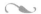

The Keystone Center, a mediation enterprise in Summit County, Colorado, conducted a difficult negotiation on "ecosystem management" a few years ago in an attempt to help resolve disputes among ranchers, loggers, environmentalists, fish and wildlife agencies, and the Forest Service. At a coffee break I asked one of the sponsoring foundation officers how we were assuring that "management" respected the limits of the "ecosystem." The sponsor replied: "That is why we invited you."

In a well-meaning attempt to balance resource protection and economic development, the sponsor had tried to give nature a fair shake by giving people like me—paid conservationists—a place in the dialogue. The intention was completely sincere, but that sincerity is a commentary on contemporary resource negotiation: some poor guy in a fishing vest gets a seat at the conference table, where he gets to cut a deal on which parts of nature are most important (which may not be known) or, alternatively, gets to guess how much something can bend before it breaks (which is certainly not known).

It isn't working. Nature is not an interest group among other interest groups, and nature cannot be represented by an interest group. Negotiation is a plausible technique only if it addresses the right question, namely: What should we do about nature? Or more concretely, what means should we all adopt to protect and restore natural systems so that they might continue to operate for future generations? Otherwise we will continue to pick up the pieces of failed attempts at "balance"—as we do now. And in the meantime, we are passing on to our children a campsite that is not as clean as we found it.

In which the author loses faith, then finds it again in the streaked snowfields of August.

◄ BANDOLIER CREEK, NEW MEXICO

The national parks of the United States are doubly successful. They are constructive experiments in conservation, being habitat refuges for any number of otherwise imperiled species, and they have passed the test of self-government, enjoying wide public support and hosting only minor controversies, snowmobiles in Yellowstone notwithstanding. They are popular enough that even some doctrinally pure free-market elected officials tolerate the park system and suppress expression of their native desire to sell them off. The parks, in a word, are eco-political success stories, and in their combination of social acceptance and biological significance have proven to be one of our Euro-American culture's really great ideas.

The national forests of the United States, on the other hand, although as equally public as the parks and managed by the same government, are by comparison a double disaster—ecologically compromised and socially contentious. The forests are not only the focus of innumerable resource controversies but are also the sites of much failed resource protection: they are heavily logged, heavily grazed, and home to a vastly overbuilt road system eroding steadily into the streams. They comprise ground zero for endangered species conflicts.

Something is badly wrong with the forests that is not wrong with the parks, and the fault does not lie with public ownership or government management. The fatuous belief that all things governmental are done badly is common enough, but the parks' relative success and forests' relative failure speaks of a nuanced world in which differing kinds of governance produce differing results, even within a close and narrow set of issues. The national parks and the national forests incorporate two distinct belief systems about managing the public estate and similarly express two competing sets of assumptions about what kind of people we are, and how we relate to the natural world.

The forests assume that nature can be successfully managed, while the parks assume that if people are successfully managed, nature will be alright. These overarching propositions are imbedded in a matrix of smaller notions, similarly contradictory. The parks, for example, assume that the natural world is fragile; the forests assume the natural world is resilient, so while the parks attempt to avoid harm, in the forests damage is expected to heal. Similarly, the parks assume that the power of the marketplace inherently threatens natural resources, while the forests obediently try to balance market forces with resource protection, with the consequence that the parks generally prohibit

most forms of private for-profit enterprise (except the concessions), while the forests explicitly subsidize profits.

Ultimately the parks are predicated on the belief that people like us are best managed by regulation, while the forests rely on faith in our wisdom and judiciousness. It is "We are the kind of people who cannot be expected to maintain natural resources without strong rules to restrain ourselves" versus "We are people who can effectively balance the needs of nature and our own needs—if we just had the budget."

It comes down largely to regulation. The national park system is an excellent example of management by regulation that constrains the full exercise of the free market so apparent just outside park boundaries. The Forest Service, on the other hand, attempts to manifest the faith that a good planning process can balance self-interest and the needs of the natural world without much explicit regulation. In pursuit of balance almost anything within a national forest is potentially subject to an elaborate planning process, and always has been. In the early days of the national forests, for example, cattle grazing on the just established Tahoe forest was permitted if the forest supervisor allowed it: there was no outright regulation one way or the other. There still isn't. Clearcutting, cattle grazing, mining, and road building are all permitted in national forests if the supervisor deems it allowable and makes a show of a detailed public process. The national forests are a collective expression of the belief that we are wise enough to decide how much use nature can tolerate.

Faith in ourselves reaches its zenith in the multiple use/sustained yield legislation of the 1970s, language that is still in place. This commonsense approach captures a deep optimism not only that nature can be managed but managed well enough that the full range of forest values can be exploited at a substantial level and simultaneously sustained.

That optimism has not borne out. Several of the "multiple uses" have been found to be incompatible (owls and logging, off-road vehicles and silence, roads and clean water), and the yields of the values the public most wants— clean water, old growth, fish and wildlife habitat, irreplaceable recreation, spiritual solace—have been steadily declining for decades. Under the multiple use/sustained yield policy, irreplaceable forests have been logged, species have been driven toward extinction, and thousands of miles of national forest streams have been polluted solely by the erosion caused by federally permitted grazing, logging, and road building.

We don't know enough to "balance" these issues—any attempt at balance is pure guesswork. Faith in our skills as managers of nature and trust in balanced decision-making processes do not change the basic fact that thousands of species depend on healthy ecosystems. But "balance" is such a politically palatable concept (and serves for-profit interests so well) that it continues to reappear in new guises, despite its failed record and its lack of intellectual underpinnings.

The national forests are the corporeal expression of the belief that we know what we are doing; that uncertainties about the workings of the natural world have largely been dispelled; that errors in the management can be detected and ameliorated soon enough to avoid permanent problems. The parks operate on a darker and more Protestant outlook that supposes we are a flawed and self-interested people manipulating a perishable world where much is unknown and likely to stay that way. This essential difference in the estimation of the extent of human fallibility has resulted in a park system that is the envy of the world, and a national forest system that is cut-over, conflicted, and imperiled.

Balance has failed. Multiple use/sustained yield has failed. Faith in the efficacy of planning and management has been misplaced. Americans in the West have not found a way to protect natural systems while extracting substantial resources from them, although we continue to try.

Ominously, the time may have passed when we might choose the outright protection of public values over private profit. Arguably, you could not restart the national park system today. In the founding of the parks in 1872, we deliberately chose protection of nature over the pursuit of profits, and we said so. But by 1972 or thereabouts we put our faith instead in our own wisdom, choosing process over protection, procedure over regulation. Those trends are even stronger today.

Perhaps people in the nineteenth century were less delusional than we are—perhaps a now lost candor required them to admit that strong rules were needed to contain strong desires, coupled perhaps with an optimism that plenty of opportunity for exploitation existed elsewhere. Maybe the world has changed; more likely, we have.

❧

The Keystone resort sits high in the drainage of the Colorado River, just below the Continental Divide. Out my hotel window, the summit ridge lines are streaked with the dwindling snowfields of August, some of whose meltwater will ultimately irrigate Los Angeles. I store this windswept image in a mental file labeled "Scenes of Wonder and Curiosity," put on my vest, and drift downstairs to the negotiating session, more unsure than ever that I know what I am supposed to do there.

Sometime during these Keystone meetings I began to be troubled about "balance"—although at that time my concern was ill-formed, and I did not see much of an alternative. But I was slowly coming to wonder whether the fundamental fit between ourselves and the West had changed since the founding of the national parks. I was beginning to wonder whether apparently reasonable contemporary rhetoric (about balance, for example) insulates us from thinking about our share of the continuous and largely irreversible erosion of natural systems. Perhaps a sense of balance allows us not to question our results, since our motives are good.

I still wear vests to meetings, although in the intervening years I have found one or two that look a little more businesslike, and a little less like they ought to have ragged trout flies hooked into the pocket flaps. But I no longer have the illusion that balance works. Nowadays when I look out my window at the scanty snowpack on the Continental Divide, I am not wondering, I am certain—certain that the test of what kind of people we are, and what kind of West we really want, is already upon us and has been for a while.

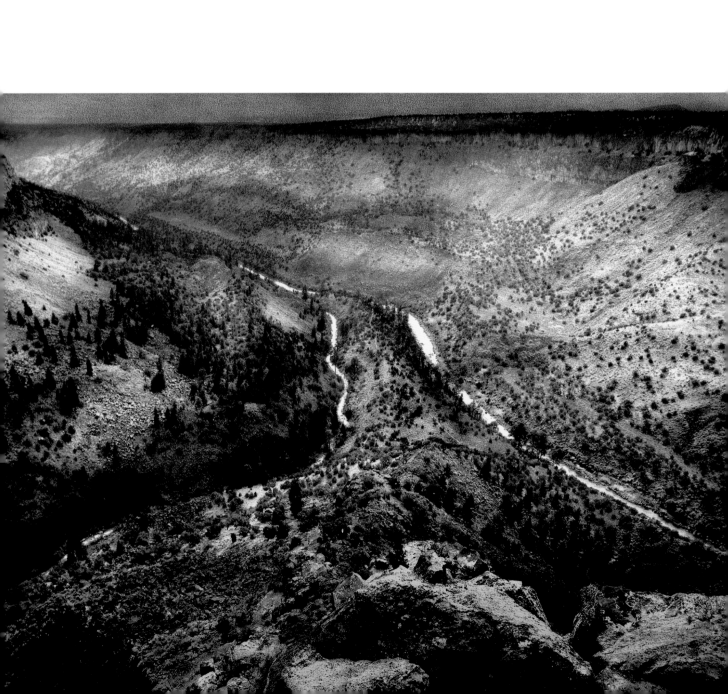

‿

My son Ezra and I went fishing near his home in northern New Mexico in March of a year not long ago. In New Mexico, in March, it can still be winter in the mountains but is generally springtime in the valleys, and, as it happened, this particular March the lower-elevation creeks were already running high and muddy from cold snowmelt.

The only chance at good fishing—not a very good chance—was at a stream below a dam, where flow, instead of being naturally and appropriately high and cold, is regulated by the operation of the dam. Some of the best fishing in the West is just downstream of dams, and what the word "best" means in that sentence requires an extended and depressing entry of its own.

We drove over the pass from Taos to the Upper Chama River, near the very top of that exceptional valley. We fished below one of the dams, but the water was as high and cold as we feared, and the fishing was terrible. We gave it up fast and headed downriver—the long way—back to Taos on a road that paralleled the length of the river. It was a textbook northern New Mexico afternoon, and the light was beautiful, just a shade away from stormlight.

If I had ever seen this valley before, I had no reason to remember it. But as we drove, the colors and shapes of the hills seemed familiar. The familiarity was unexpected, but with each turn downriver it got stronger.

Eventually we rounded a big bend in the road, and there was something more than familiar—something I knew: a high, dark narrow mesa, its top tilted toward the southern sky. I knew that hill, and the feeling of knowing was palpable. (Feeling is not one thing and knowing another. Do not try to oppose them and start a needless quarrel.)

We make sense of the West the way we make sense of anything, no better, no worse.

◄ CONFLUENCE OF THE RED RIVER AND THE RIO GRANDE, NORTH OF TAOS, NEW MEXICO

Around the next curve we faced a wall of scrubby ocher bluffs, dotted with piñon and juniper. I realized then the familiarity's source—I knew the dark mesa and the scrubby bluffs from Georgia O'Keeffe's landscape paintings, some of which (abstractions or not) are so accurate in their essential depiction of the land that, I now know, they can generate decisive familiarity, which is unequivocally a form of knowledge, however secondhand. This all is only a minor and obvious point of epistemology: what we know about the landscape includes things we have seen only in paintings—and photographs, of course. But this is not a story about painting, or the power of O'Keeffe's images, or anything similar. It is about how we know what we know, how we know where we are and who we are. It is about the comingling of knowing and feeling, seeing and experience, and about the fruitlessness of drawing distinctions between those things. This is a story about seeing what you already know, even when, or especially when, you know something from a work of art.

The West I see is the West I already carry in my head, even where my familiarity is secondhand (through paintings or photographs), or thirdhand (irony topped with paradox, since I mostly have not seen the actual O'Keeffe paintings, but reproductions of them). I see the West through an oceanic accretion of images that have drifted down past consciousness to rest at the bottom of my least accessible regions. For better or for worse, my West is my West, and there is no easy and obvious way to tell if it looks like yours or anyone else's.

In the familiarity of a dark hill lies the ordinary problem of eyewitnessing. We cannot be trusted not because we are flawed (Adam), but because of the nature of seeing (God's gift). Very seldom do the shapes of mesas or the colors of piñon-studded bluffs get the penetrating attention of an O'Keeffe and very seldom do they become objects of knowledge, particularly common knowledge. A drive through much of the West produces a limitless stream of views of piñon-studded bluffs, none of which will have marks of familiarity to them. It is not that we do not see these hills—we always see them—it is that the mechanisms by which we make sense of them are not so obvious as they are on those rare occasions when we are shocked into self-awareness by the force of the vision of the artist.

Seeing, in a word, is seldom like it was that afternoon on the Chama. Seldom is knowing rooted in vivid or identifiable sources. While we always see what we already know, most all the days of our lives the sources of knowing are too subtle, too far gone, too ordinary, too slippery, too featureless, for us to pause and notice the miraculous and undependable nature of it all. If we think about it at all, we may think we see the piñon-studded bluffs as they are. We do not. We see them the only way we can.

WHERE ARE THE WILLOWS?

An acquaintance of mine—a scientist who must remain anonymous for reasons that will become obvious—has spent the last several field seasons researching changes underway in the fundamental ecology of the Lamar Valley of Yellowstone National Park. He is finding evidence that comments pointedly on the uncertain trajectory and hazy naturalness of that resplendent region.

But he is extraordinarily cautious in telling me or anyone else too much about his research. His uncharacteristic caution rests on the flat contradiction his findings present to the park's own theory about its northern range. He is worried that permission to do research in the park will be withdrawn when word of his upsetting work gets back to park headquarters, and he wants to publish the research first.

Neither my friend's questions nor his caution is anything new to this park, or the West, for that matter. There has been a scientific dispute about the ecological status of the Lamar Valley—particularly concerning browsing by elk—since before I was born, and although the dispute involves some intricate scientific complexities and some intriguingly rough politics, it boils down to the same question: how natural is this valley, anyway?

Perhaps surprisingly, the question has a high enough profile that in the late 1990s the United States Congress called in the National Academy of Sciences to address it. The academy met, reviewed the literature, walked the ground, interviewed the experts, and then wrote a report on the Ecological Dynamics of the Northern Range—which could have been called Grazing in the Lamar Valley, or even Where Are the Willows? Its conclusions are hedged so adroitly that you have to read carefully to figure out whether there are any

There is hardly any moment when humans are more delusional than when self-recognition is required.

◄ ELK-PRUNED, BEAVER-
GIRDLED COTTONWOOD
IN A BISON-CROPPED
MEADOW, YELLOWSTONE
NATIONAL PARK

conclusions at all. When need be, the academy mumbled artfully, "defining natural is difficult," which did not, however, stop them from using the term continuously. The academy's imposing report, instead of putting controversy about grazing on the Northern Range to rest, seems to have added a booming if ambivalent voice to an already inchoate chorus. Perhaps other outcomes were never very likely.

Science is a form of knowing, one member of a large set of routes to knowledge that includes ordinary vision. Hardly anything will better sharpen your ordinary vision about a place you know well than to read warring scientific papers about it and then to walk the familiar ground again. I try to find my way through the thickets of thinking and seeing in the Lamar Valley, but my growing intellectual unease there is matched by my increasing awareness that any old valley would do. The Lamar, like the West itself, echoes the universe at large: in the Lamar (as in the cosmos generally or any other place in it), everything is relative to everything, everything is in motion, and there is no privileged point of view from which objectivity is assured. If you want to know how you know what you know, one valley is as good as another.

In other words, for me the Lamar is, arbitrarily, the valley of personal epistemology: the place where my awareness grew that my own seeing is in flux and contingent on happenstance; where I became aware once again that science, like all else human, is disarrayed, mindful that saying-what-you-see is a political act. Over a dinner in Portland, my scientific acquaintance and a colleague argued for an hour over the appearance of various plants at the epicenter of the Northern Range—the confluence of Soda Butte Creek and the Lamar River. The argument was respectful but tough. My own uncertainty, it appears, if not well founded, is at least widely shared among those for whom seeing is inseparably linked with doubt.

But specific things happen in specific places, even if they could have happened elsewhere, even if all places are equal. We grasp the general—when we grasp it at all—by seeing particulars, and by example, and even by analogy. I have not reached the point of spiritual equanimity where I know in my gut that everything is connected with everything, so—a laggard perhaps—I remain in the grip of places that seem more equal than others.

And in the grip of the Lamar I have become aware of my limitations in seeing my own land. However paradoxically, I have become conscious of my blind spots. I am at least aware of them. Sometimes I fail to see that young willows are missing, but sometimes their absence is visible. I am trying to

untangle the landscape from knowing-about-the-landscape, blind spots notwithstanding.

I was slow to grasp that I suffer an inherent inability to see my own land clearly, but as my awareness of my limitations grew, so did their importance. And I am not the only one. The longer I have looked and the more closely I have questioned, the larger my concerns have grown, the more universal they have become, and the more certain I am of ambiguities.

So, in the end, is the Lamar Valley overgrazed? I think it is grazed so hard that the willows are gone, and the beaver are starving—they try to take down full-grown cottonwoods, for which no replacements are in sight. In the open ground in the center of the valley are cottonwoods whose trunks are completely girdled by beaver, who work on a difficult food source like this only when easier fare is scarce. The crowns of these trees are curiously shaped, the leaves shorn by browsing elk, the meadow clipped by bison. Every large element of this landscape is shaped by local animals' eating habits. And along the lower Firehole River, more of the same—there are no willows where there ought to be willows, a piece is missing from the jigsaw. But while I think the overgrazing is apparent, I know for sure only that my seeing is in flux. Since no thing is fixed, only uncertainty is assured.

My personal assessment of the Lamar Valley has changed with enough frequency and degree that I have come to believe that when I look "out there," I mostly see my own likeness echoed back from the cottonwoods, the water, the austere valley. An echo is shaped partly by the shout and partly by the canyon wall, and the returning sound, however hollow, however late, is still faithful both to the reflector and to the thing reflected. Blind spots are not some failing of mine, rather they are intrinsic to the nature of vision, and to the imperfect ways we know ourselves, echoes and all.

Our confusion is yet another manifestation of an interestingly varied universe, whose inexplicability, like blind spots, is inherent. There is no new thing in the West. Despite my seamless descent from a perfect, limitless, unfenced cosmos, my distinctive mix of seeing and knowing—and yours—is haphazard and prone to error, although I see no inborn reason it should be. My vision is contingent and unreflective—habitually short on self-awareness. Struggle is required to make it otherwise; taking myself for granted does not take me far enough.

I believe that to live in peace with the West we need to change, and more than anything else, we need first to see ourselves clearly and second to

recognize our blind spots. But when the need is greatest, we do not recognize ourselves; the echoes of our own voices do not sound familiar. I want to see *my* hand in the landscape, but it is not so easy.

In the Lamar Valley, beaver gnaw the trunks of cottonwoods, elk browse their leaves. The shadows are long, even in summer. Even so, it is just another place. In it, just as elsewhere, we see the marks of our own hands faintly because we don't have to know very much about the land we live in; because we are equally part of and apart from nature; and because there is hardly any moment when humans are more delusional than when self-recognition is required.

A PATCH OF WOODS

The term "wild" cannot be used without qualifications, nevertheless the largest remaining wild places in the West are mostly in national parks or wilderness reserves. Moreover it appears that there will come a time—perhaps sooner than later—when all the remaining wild places, large or small, will be in parks or reserves. Expressed differently, there will come a time when there will be no wild places outside of designated "wilderness" because today's wild places will have become fully domesticated or legally protected, and the facts on the ground and the laws on the books will be in alignment, which they are not now. (Formally recognizing and managing wild places is itself also a way of domesticating them, which contradicts the idea that they are wild, but this is no more ironic than much else about this subject in particular, or the West in general.)

But when I was a child, and perhaps when you were a child, there was wildness that was just there—unmarked and undefined, and usually unnoticed. There was wildness on the edge of town, so to speak. As a child, I was permitted to walk from my home into a bit of wildness, and it wasn't much of a walk.

There are still some such situations now, and still some such fortunate children, but increasingly, if we are talking about places with a whiff of genuine wildness to them and not just cut-over, neglected land, then the neighborhoods where you can walk to the wild are generally rare and pricey. Such walks are no longer common middle-class childhood experience.

Part of my childhood was spent in Houston, Texas, which—this will be hard to imagine—had enough wildness on the edge of town that you could relatively easily get lost, drowned, snake bit, or at the very least terrorized

Thoughts on the price of altering a landscape beyond remembering, and on who pays for it.

by mosquitoes voracious enough and numerous enough to lend credence to the otherwise unbelievable stories of caribou-killing bug swarms of the far north.

In those days, which were after all not so very long ago, Texas still had water-moccasin-infested coastal rivers—good venues for a canoe. But closer to home, wildness consisted of a woodland that belonged to some nameless absentee owner—a small woodlot, perhaps, but deep enough to have an interior geography known only to adventurous ten-year-olds. We found our way to the woodlot's patches of palmetto marsh or leaf-littered copperhead nests unaided, unfettered—and almost certainly unapproved—by adults.

I found wildness also in the bayous, whose abundance of frogs and turtles suggested the era of the dinosaurs. On any given afternoon I could find five species of turtle: two kinds of sliders, two kinds of snappers, and the graceful silt-colored soft-shelled turtles invariably seen only as they dived out of view. Today, those bayous still run, but in the intervening decades they have been paved with cement (in order to displace floodwater from one place to another), and they look alarmingly like the backdrop of a cinematic stage, set for an after-the-apocalypse film, where the entire mercury-vapor-lit urban landscape of the not too distant future is paved, and everything is connected by skywalks. Unaccountably, these paved streams of the apparent future have fish in them (God knows what kind) that can be seen rising regularly in the opaque, olive water.

Boulder Creek in downtown Boulder, Colorado, on the other hand, has been "restored" since my childhood—although it is unclear that it ever was what it has been restored to. When I was young, the creek was literally trashed—people abandoned their failing refrigerators along its overgrown and neglected banks, right in the center of town. Today the creek is the centerpiece of a beautiful and popular urban park, and is, I would argue, not so much a creek as a work of art—a prairie creek engineered into the image of a mountain stream, complete with trout-filled plunge pools and minor rapids where the refrigerators used to be.

Boulder Creek today is as much a product of engineering as the paved bayou—only the aesthetics are different. On the bayou, form is dictated by the needs of so-called flood control, while on Boulder Creek, pools, riffles, and boulder-strewn cascades are the product of an esthetic theory where the artist tries not to show his hand.

In the national parks, creeks retain some of their power. Their force lies in their wildness, however qualified. In national parks the illusion and aroma of wildness persists, even in places you can drive to. The pair of creeks I know best, Fall River and the Big Thompson, in Rocky Mountain National Park, have been consciously important to me since I became aware of having consciousness—and I have fished them, yearly, for forty-five years.

Physically they haven't changed much in that time, although species have come and gone—the rainbow and cutthroat trout have been gradually replaced by browns and brook trout. You could say that half a century is not a lot of time, geologically speaking, but as it happens, a flood of geological proportion hit Fall River a few years ago, when an old earthen farmers' dam inside the park failed, sending a flood downstream large enough that nature would likely require fifty thousand years or so to produce another of similar force. Although parts of the town downstream were smashed, and people were killed, the river itself in Horseshoe Park, with its streambanks armored naturally by willows, was unharmed. After a year or two, as the silt from the flood settled, fish recolonized the river, and the river is fine. What I go to the stream to find is still there, even after a biblical flood. In a healthy stream, floods are no more a disaster than is winter.

The bayou of my youth is essentially gone. Fish of some very tough persuasion are rising in its cement channels, but the turtles and frogs have vanished. The Boulder Creek of my youth, oddly enough, is also nearly gone, upgraded from a trash heap into a piece of attractive, animated sculpture.

The woods of my youth have had a more ominous fate. The woods at the edge of town in Houston (and Denver, Phoenix, Atlanta) are not just gone, but eradicated so thoroughly, suburbanized so existentially, that when I walk the neighborhoods that replaced the palmetto patches and copperhead nests, I search for a glimpse of the memory, but it is not there. I cannot find even the images of my youth. There is nothing on the ground to which memories can cling. The woods are gone, but more disturbing, the past is gone.

My memories are no longer rooted in the landscape. Not only do the places of my youth no longer exist, but the anchors for my memories have vanished. I am not prepared for this. We probably cannot live at peace with the landscape if within one generation we alter our places beyond recollection, making the one who remembers a stranger.

▶ PANORAMA, MADISON CANYON, YELLOWSTONE PARK

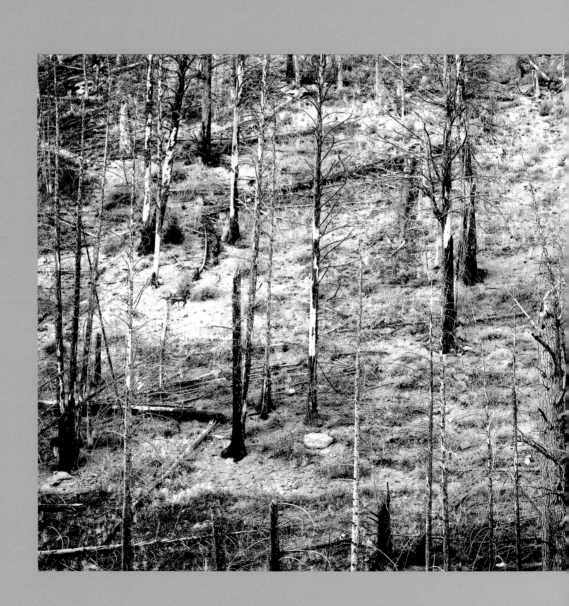

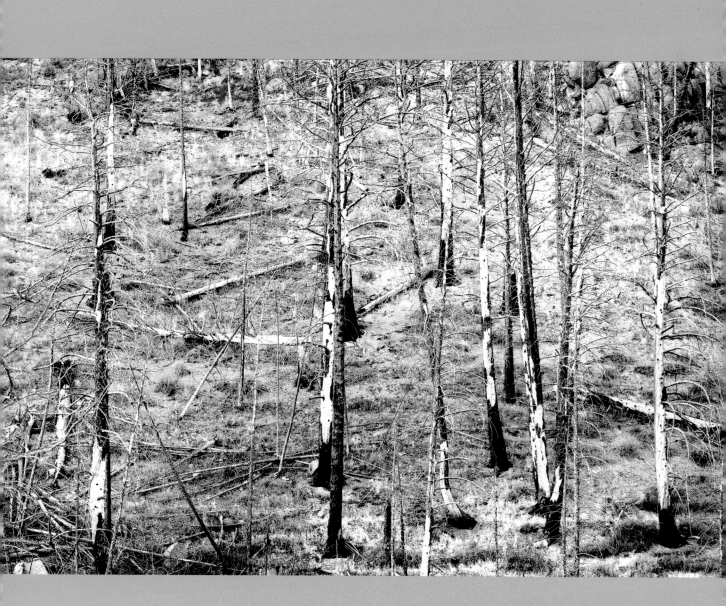

REARRANGING THE FURNITURE

∽

The prettiest valley in Summit County, Colorado, ossifying under a cold inland sea.

I was a child in the era when home movies were made not with video recorders, but with small, complicated, and technically demanding film cameras. Making a home movie, of necessity, was quite a production, and my assumption has always been that given the difficulties, my family's movies were only made concerning Things of Importance, things worth a certain amount of hassle, not to mention expense.

A fair number of our home movies, then, concerned family outings to the recent marvels of 1950s engineering, especially dams. The 1950s, of course, were the salad days of public works—the high-water mark of dam, power-plant, and interstate highway building. Perhaps my family movies just reflect the times, but whatever the case, our film archive houses jumpy black-and-white images of me as a child looking up at the incomprehensibly large face of a half-built dam, and staring at an electric turbine the size of a bank, and emerging, blinking, into the sunlight from the black mouth of an almost completed tunnel.

At the age of four or five, I was taken to the face of a dam in the making in Summit County, Colorado. I have known since that sunny afternoon that the prettiest mountain valley in all of Colorado is gone from view, beneath the frigid waters of the resulting reservoir on the Blue River fork of the Colorado River. Underneath today's featureless expanse of windswept water (right there, by Keystone ski resort) is the quintessential Colorado mountain valley and its derivatives: a classic trout stream, small town memories, family ranches, log buildings, dark forests—all of them ossifying slowly under a rain of fine silt, at the bottom of a cold inland sea.

As my family and I watched the trucks hauling cement to the growing face of the dam, my father pointed up the hillside to a spot far above our heads where the final waterline of the reservoir would be. I remember the doomed landscape and the doomed stream. I know what it looked like.

The dam and the reservoir were built for the usual boondoggle reasons, but the joke is on the boondogglers because the irrigation water that fills the reservoir is worth vastly less today than the land underneath its frigid waters. For a couple of decades Summit County, Colorado, has been in a race to the bottom with Clark County, Nevada, for the honor of the nation's worst and fastest overdevelopment. Your average Colorado mountain real-estate developer would give his firstborn child—plus a couple of points—for a chance at another valley like that one. But it's gone.

My favorite family movie documents our picnic at Mary's Lake outfall in Boulder County, near Estes Park. A minor but visible part of the giant Colorado Big Thompson project, the outfall is the working end of a literal siphon: a faucet that controls the flow of parallel 12-foot-diameter pipes underground, large enough to lift a minor river's worth of water from the reservoirs on the western slopes of northern Colorado, over the Continental Divide, and down to alfalfa farms on the high plains—and, incidentally, under Rocky Mountain National Park. Not to put too fine a point on it, but for those few connoisseurs of western surrealism not already familiar with Western Water: a good-sized chunk of the Colorado River flows backwards, literally uphill across the Continental Divide in a tube under a national park, on its way to New Orleans.

The people who built the Big Thompson project and the Blue River reservoirs thought we could have the West and engineer it too, or that the West would still be there after we rearranged the furniture—so to speak.

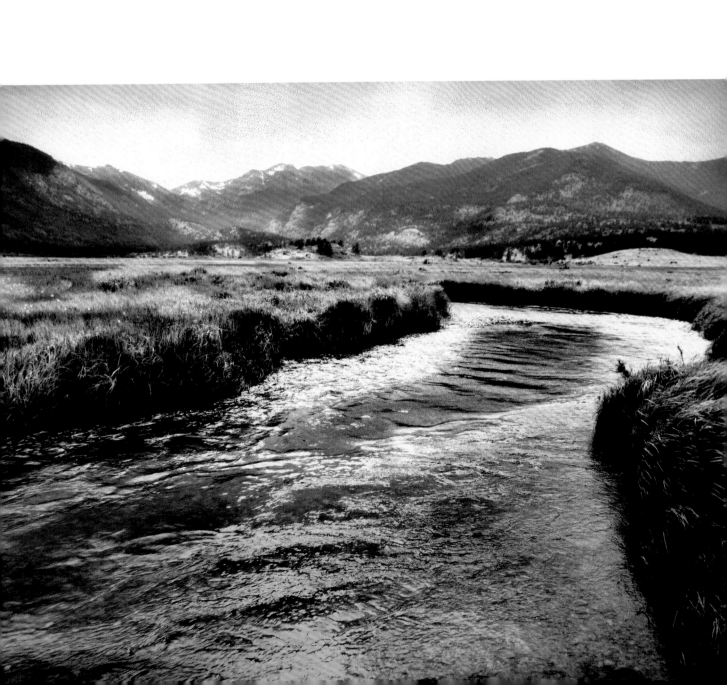

TWO TROUT

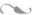

When I was young, I fished mostly by myself. It was easy to be alone on a trout stream in the 1950s, even in the middle of Rocky Mountain National Park. There were not so many people fishing those places then.

In the mornings my parents would drop me off alone in one of the meadows at the foot of the front range peaks, meadows which locally are called parks—Moraine Park and Horseshoe Park. These are the last meadows on these headwater streams; upstream from the meadows are cascades, and upstream from that are snowfields. Fall River in Horseshoe Park flows to the Big Thompson, then into the South Platte, the Platte, the Missouri, the Mississippi, and, downstream from New Orleans, into the sea.

In my memory, at least, I fished alone because I wanted to, because no one I knew fished, because my parents were preoccupied with their own somewhat difficult lives, because as a family and as individuals within that family we were somewhat isolated, because being alone came naturally. Finally I fished alone because my parents, both by instinct and intellect, understood that leaving an eight- or ten-year-old child alone in a safe enough but nevertheless wild place was a way of investing in that child. It was an investment that lasted.

If the day was spent in Moraine Park on the Big Thompson, I could walk home over the hill to our rented cabin. The glacier that had formed the meadow also formed the hill—the moraine for which the park was named—and the walk home was not only strenuous but also offered plain lessons in both geology and esthetics. It was a long time before I recognized either of them.

An elegy concerning family and memory, child and man.

◄ BIG THOMPSON RIVER, MORAINE PARK, ROCKY MOUNTAIN NATIONAL PARK

I do not remember how I got home on days when I fished in Horseshoe Park on Fall River, which was the next drainage north and too far to walk. But I do remember the day on Fall River when I saw the Great Trout that makes an appearance in all trout stories—the trout longer than my forearm, the trout with black spots the size of dimes, the trout deeper-bodied than a large man's hand, the faintly reddish golden trout, the trout that was then still called a German brown, the trout that without any bodily movement at all rose up from the amber depths until it was under my absurdly large and gaudy fly. The fish, drifting backward with the fly, considered it precisely as the large fish always does in any story where he does not then take it: he simply stopped drifting, and the fly floated on by.

Even at ten years old I knew enough to try changing my fly for something better, although I had no idea what was better and my hands were shaky. Even at ten years old I knew I was in the presence of memory, and I could feel the image of the fish becoming fixed, as it is fixed now and will remain. I noticed even then that something about the clock had stopped, although I did not know it would stay stopped nearly until now.

I hurriedly tied on a new fly. And, as in all big fish stories, I made a mistake, casting badly and dropping a spattering line on top of the fish, which in a meadow stream was only 15 feet away from me. The fish disappeared.

I told my family about the fish. It sounded so much like a fish story (even to me) that I still occasionally wonder whether I had really seen such a big fish in such a high meadow. It was not that my family did not believe me but that memories from childhood frequently elide things that happened with those we hoped had happened. Retold stories eventually take the form of memory, like pictures from albums from before we were born become merged into our experience, the way the early morning ringing of the bedside phone becomes part of the last dream of the night.

Forty years passed. When I saw the fish again, I had children who had grown, and who themselves fished the same streams, although mostly they do not fish alone, as I no longer fish alone. In the intervening decades my father and I had learned to fish together, or more accurately, we had learned to fish in parallel. He would fish one fork and I the other—generally I on the left fork and he on the right, or Spencer's fork.

The day came when the fish appeared again. It was not the same fish, of course; a brown trout might live twelve years, but not forty. But it was the same great fish of the stream, the fish that confirmed at nearly forty years' distance that a ten-year-old in a wild meadow can see clearly and remember well. The

fish confirmed the value of a child's time and confirmed the instincts of the parents—although one of them had passed.

My father saw the fish first, four feet deep in a straight run just off an undercut bank—not exactly where I would expect it, which shows that I still have a lot to learn and incidentally probably explains why the fish lived long enough to grow to that size.

I saw it half an hour later in the same run. It was an old male German brown trout, not quite two feet long—a predator, a fish eater, the top of a food chain. My dad saw it, I saw it, and we each knew what we had seen. The rest of the story is anticlimactic—the fish was caught and laid briefly on the grass for a photographic imitation of a nineteenth-century trophy painting and then put back. And without pause, the mergers began of image and story and memory.

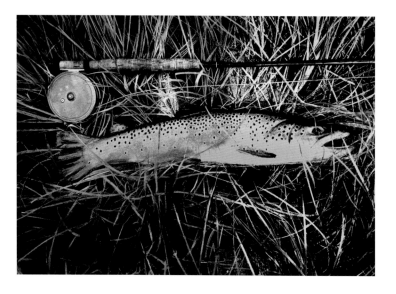

THE CAMERA AND THE FLY ROD

When I am outdoors, I almost always carry a fly rod or a camera. Not usually both, but seldom neither. For a decade or so, I carried the one, then for a decade the other, until eventually it dawned on me that for most of my purposes the fly rod and the camera were essentially interchangeable.

An elegy concerning a crazed weasel and a wounded beaver.

Each of them is a divining rod. If you hold a camera or a fly rod in your hands just so—not trying to impart your will on them, but rather taking your direction from them—either can lead you unerringly, if perhaps slowly, to beauty, even, if you are lucky, to peace.

I was a few decades into it before I began to realize I wasn't really looking for either photographs or trout. There is nothing uniquely or even particularly western about seeking peace through a mechanical aid, unless of course you think of that sort of endeavor as another perversely good example of the needlessly complex relationship with nature characteristic of western men—which I do, and count myself among the seekers, learning to see as best I can.

To use the camera or the fly rod well you have to be graceful, adaptive, and accepting, and what's more, you must be willing to be those things, which may be harder yet, perhaps especially for men. The qualities of responsiveness and acceptance make a camera or a fly rod useful tools for finding a path across the divide between you and nature—qualities that may not come easily to men in our tough culture, which is hard on men and hard on women in differing, even contradictory ways. To photograph well, you have to give up your native seeing and align yourself with the camera's vision, just as to fish well you must learn to accept that it is the fish and the way the world works

◄ CHAMA RIVER VALLEY, NEW MEXICO

that counts, not you. In fishing and photography it is partly the depth of your acceptance that matters, not your dreams, wishes, strengths, desires.

In their capacity to show the way to beauty, and in their insistence that you at least try to see the world for what it is, a camera or a fly rod is perhaps a very good western companion—but perhaps not. Barry Lopez explored this territory and found that, for him, putting the cameras away was a necessary part of learning to see. For others it is the opposite. For others yet—and I may be one of these—the ideal is perhaps still to carry the camera or the rod, but to outgrow urgency in their use.

The fly rod has been so much a part of my love of the West that one of the jobs I most wanted to get right as a parent was passing that on to my children. As first my daughter, Shannon, and then later my son, Ezra, reached the age of seven or eight, I taught each of them to cast a fly, and tried to show them once or twice how to observe what the fish were doing. I did not do much more than that and, as regards fishing and many other things, after I taught them to cast and encouraged them to look, I mostly left them alone to find their own way. Now, twenty-plus years later, both of them cast flies well—expertly, in fact—and both know where the fish are. They own their own fly rods, so to speak. Their self-made skill and their engagement in matters of their own choosing embodies one of my proudest accomplishments, not because of the fishing, of course, but because of where the divining rod has taken them.

Shannon was fishing at Sprague Lake in Rocky Mountain Park when a ground squirrel, fleeing for its life, scrambled out of the brush, across the trail, and disappeared under a rock beside her. Shannon wisely stood completely still. Seconds later the pursuing weasel, hell-bent on making a meal out of the squirrel, scrambled out of the brush too, but couldn't locate his prey. Shannon remained quiet. The weasel, glancing around, stood up on his hind feet and, extending a paw, braced himself against Shannon's bare leg as he continued to survey the trail. A minute passed. No squirrel. The weasel walked away.

(It's always a little dispiriting to tell a story about a weasel, with its suspect and maligned name. Just note that a weasel in the wild is a tough, smart, carnivorous predator and, mirabile dictu, turns white in the winter, becoming, at least in the nomenclature of furriers, an ermine. But I guess I wouldn't want to tell a story about an ermine, either.)

Ezra was fishing the backcountry on the Cimarron fork of the Arkansas River in northern New Mexico when he came across a large male beaver in the streamside willows, live but wounded—caught in a leg-hold trap. After

assessing the options and putting his rod aside, Ez began to talk to the beaver—letting him know what he was about to do. He explained to the beaver that he would have to lift him up to get to the trap, that he would have to open the trap with both hands, that it would not be easy, that it might hurt, but that it was the only way to free his bloody leg. As he continued to speak, Ez gradually lifted the heavy creature and pried open the trap. For a moment the liberated animal did not move—and then he slipped into the river, but instead of swimming away, perched upright in the water and for a long minute stared Ezra directly in the face.

You cannot ask more of a fly rod—or most anything else—than that it lead you to a crazed weasel or a wounded beaver and to a choice of what to do about them.

◦〜

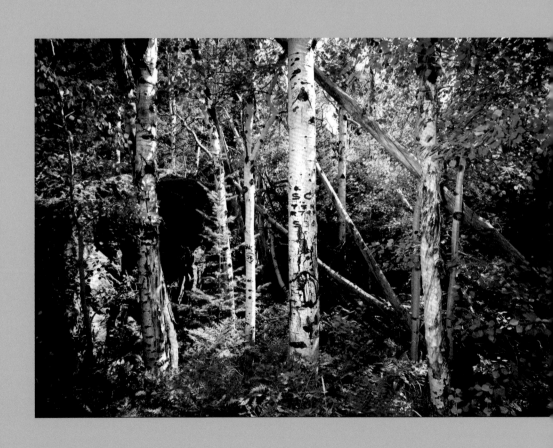

UNCERTAINTY AND OTHER SURE BETS:
A POSTSCRIPT

∽

I have no real reservations about the time I have spent trying to make sense of the West, whether I have done so or not. I hardly had a choice—an obsession with my place, and our place, in the western landscape has burned in me since childhood.

I frequently wonder whether trying to make sense of the West itself makes sense. Am I looking for things that can be found? Are human affairs sensible? Is the West? On balance I am not at all sure anything human necessarily makes sense, even though much is understood, and more understanding is sorely needed.

I have come to believe that such understanding of our affairs as we have generally comes through art—or activities that could easily be called art if use of that word were less problematic. But neither the West (nor anything else) needs to make sense to be the material of art. David Byrne, the musician and artist, admonished us all to "stop making sense." I wonder, though, if we ever started.

Knowledge of human affairs is remarkably messy—history is not a science, laws of human nature have not been found, nothing is systematic. Artful judgment and artful insight have guided our self-awareness, not rigor, not science, not statistical analysis. (Not everything yields to rational inquiry. The art of ad hoc theorizing may, in all of its uncertainty, be as good as it gets.) This may be in the nature of human affairs. The things we want most to explain—our occupation of the West, for example—may be so embedded in their context that they resist the abstraction required for objective analysis, and allow only story, metaphor, or hunch—the play as understood by the players, so to speak.

Such knowledge as we have of human affairs generally comes through art, or things that would be called art if the use of that word were less problematic.

◄ ASPEN USED AS SURVEY
SECTION CORNER, ROCKY
MOUNTAIN NATIONAL PARK

The West we have simultaneously inherited and created may be so ripe with particulars that themselves are matters of happenstance that any tidy or coherent explanation will inevitably create false precision, like the signpost at the city limits displaying a town's improbably specific population. Any story that makes too much sense of the facts of the West may be unfaithful to its true but irreconcilable sources. It is no surprise that the future is uncertain and the past implacable—both are likely to stay that way. What is surprising is the undiminishing uncertainty of the present. In the West we have made, it may remain difficult to be very sure where you are for some time.

▶ STUMP AMONG TREES,
OREGON

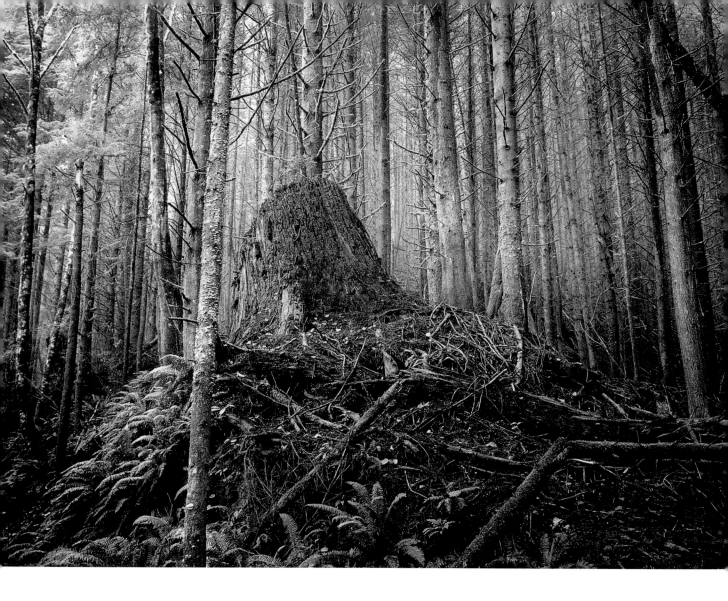

Typeset in Emigre Filosofia, by Zuzana Licko, 1996,
with display type in Monotype New Clarendon
Printed on GardaPat 13 paper by Cartiere del Garda S.p.A.,
Riva del Garda, Italy

Photographs by David Bayles, except pages 24 (Spencer Bayles),
47 (Robin Voss Robinson), and 74 (anonymous).

Edited by Suzanne Kotz
Designed by Jeff Wincapaw
Color separations by iocolor, Seattle
Produced by Marquand Books, Inc., Seattle
 www.marquand.com

Printed and bound by CS Graphics Pte., Ltd., Singapore, in an edition of 2,000

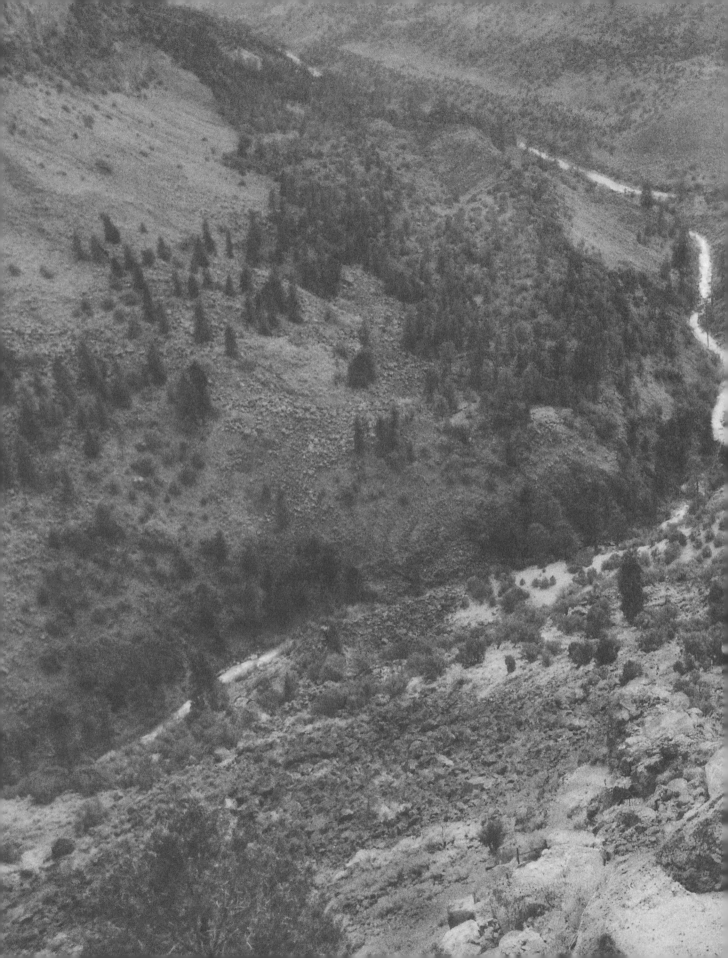